IMAGES of America
CROCKETT

Images of America
CROCKETT

John V. Robinson

Copyright © 2004 by John V. Robinson
ISBN 0-7385-2914-1

Published by Arcadia Publishing
Charleston SC, Chicago IL, Portsmouth NH, San Francisco CA

Printed in Great Britain

Library of Congress Catalog Card Number: 2004106568

For all general information contact Arcadia Publishing at:
Telephone 843-853-2070
Fax 843-853-0044
E-mail sales@arcadiapublishing.com
For customer service and orders:
Toll-Free 1-888-313-2665

Visit us on the internet at http://www.arcadiapublishing.com

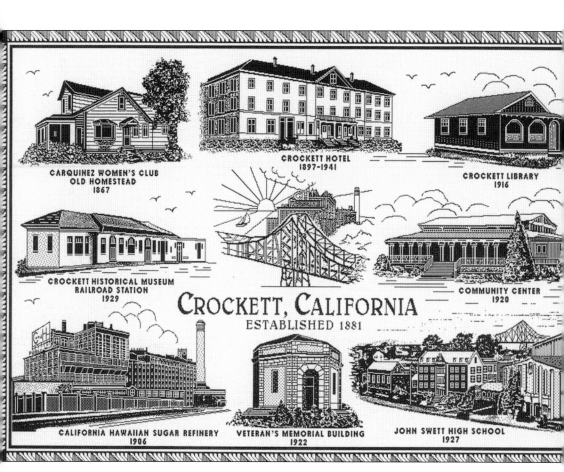

Contents

Acknowledgments		6
Introduction		7
1.	Port Costa	9
2.	Eckley	25
3.	Crockett	29
4.	Crolona	81
5.	Valona	99
6.	Vallejo Junction	111
7.	Selby	115
8.	Tormey	121
9.	Oleum	125
References		128

ACKNOWLEDGMENTS

This book would not be possible without the kind help of several people. First, Keith Olsen and Leo Cid of the Crockett Historical Museum helped me locate many of the photographs in this book. Keith Olsen and Dick Boyer have both published numerous articles in the *Crockett Signal* about the early history of Crockett and the people who built our community. Their articles were an invaluable resource to me as I compiled this book. As a pictorial history the scope of this book is necessarily limited. I would encourage anyone who is interested in a more detailed account of Crockett's history to visit the Crockett Historical Museum and consult with Keith Olsen. They should also pick up a copy of Dick Boyer's *A Short History of Crockett* and *Stories of Crockett*.

Likewise, Betty Maffei and the staff at the Contra Costa Historical Society were an important source of photographs for this book and provided a wealth of information about the history of the south shore of the Carquinez Strait. We all owe a great debt of gratitude to the people in our communities who work to preserve our local history.

Lastly I would like to acknowledge H.B. Hosmer, the C&H Sugar Refinery photographer who, starting in the 1910s, carefully documented Crockett's development for the better part of two decades. Many of the images in this book are from the Hosmer collection at the Crockett Historical Museum.

In closing, I make no claim to comprehensiveness in this book. The history of the area is too complex to be detailed in so short a work. Although I have tried to be as accurate as possible, this book may contain some oversights or inaccuracies. Therefore, this book should not be taken as a definitive history of this area. That book has yet to be written.

—John V. Robinson
July 2004

Introduction

The first inhabitants of the Carquinez Strait were the Karkin Indians who lived in the little valley where Crockett sits today. A small creek runs through Crockett, and the Karkin Indians had a small village near the creek on the shore of the strait. Early Spanish inhabitants first explored the Carquinez Strait and documented its native population in the 1770s. The Karkin Indians were described as having a sturdy build and being generally friendly to the Spanish. The Spanish report that the local natives gathered berries and nuts, trapped small game, fished with nets, and traversed the waterways in canoes made of tule reeds. The climate was mild and their needs were few.

How and when the natives were displaced from the land is a complex and troubling question. Most were forcibly relocated to Spanish missions. Historical records indicate that epidemics of smallpox, measles, and tuberculosis in 1833 and 1838 decimated what little remained of the native population and put an end to their traditional way of life.

The Europeans who inhabited this part of the state were primarily Spanish and Portuguese, with some Russians and English inhabitants in the northern part of the bay area. The Spanish flag flew over the state until Mexico gained its independence in 1821. The Mexican government then began issuing land grants to help settle the area. The land that Crockett sits on was part of one such grant known as Rancho Canada del Hambre. The rancho period lasted until Mexico ceded the territory to the United States through the Treaty of Guadalupe Hidalgo in 1848. With the change in government came the formidable legal challenges of establishing who had clear title to a given parcel of land. That is where Joseph Crockett comes into the story.

In 1865 Joseph Crockett, an attorney, helped to settle a land grant case for Theodora Soto. As payment for his legal services, Crockett was given a 1,800-acre parcel of land along the south shore of the Carquinez Strait. The property had one mile of shoreline and extended three miles to the south. The town of Crockett now sits on this parcel of land.

To protect his property from squatters, Joseph Crockett invited an old friend, Thomas Edwards, to come and work the land. Edwards, his wife, Mary, and their six children arrived on the property in 1867. The Edwards family built the house, which today is known as the Old Homestead, on the site of the old Karkin Indian village. The Edwards planted crops and raised livestock and delivered their produce to market in a little boat called The Plowboy. Their little farm was known as the "Chicken Ranch."

The modern era begins for us in 1878 when the Central Pacific Railroad decided to build its southern ferry transfer slip at Port Costa. The first task was to lay tracks along the south shore of the strait. The first trains were ferried between Benicia and Port Costa in 1879. With the coming of the railroad, development was swift all along the south shore of the Carquinez Strait.

Port Costa was growing fast thanks to the industry of local businessman George Washington McNear. A vast collection of warehouses and docks stretched from Port Costa to Crockett, and the Carquinez Strait quickly became the largest grain port on the west coast.

The railroad tracks passed right in front of the Edwards's homestead. It must have been clear to Thomas Edwards that the coming of the railroad and the deep water of the strait would bring numerous other business opportunities to the undeveloped area.

In 1880 Thomas Edwards bought the land from Joseph Crockett for $30,000 and, along with businessman John Loring Heald, laid out a town site. Several names where proposed for the new town, including Edwardsville, but Edwards decided to name the town Crockett in honor of his old friend.

Soon after, John Heald started building a foundry on the western edge of town and built a large hotel to house his foundry's workers. This hotel stood at 707 Loring Street for more than 110 years and was know through the years by the names Pinkerton House, Crockett House, and Traveler's Hotel.

At the same time, Abraham Starr arrived to begin constructing his Starr Mill that, in reference to the Roman god of agriculture, he declared to be a "Temple to Ceres." Starr built the Starr Hotel to house his workers. (Many readers will remember it as the Starr Apartments that burned in the 1970s.) Starr's Mill was one of the finest in the world and was the nucleus of today's C&H Sugar Refinery. Although Starr's business failed, his mill was good enough to attract other business ventures to the site. The "Port Costa grain king" George Washington (G.W.) McNear operated the mill for a few years, before Hawaiian interests brought the factory in 1906, converted it to process cane sugar, and started the C&H Sugar Refinery that we know today. None of this would have happened if not for Abraham Starr's failed dream of building the finest flour mill in the world. Crockett was not to be known for its flour, but for its sugar.

From the hill to the west of Crockett, Dr. John Strentzel also saw the developing business opportunities along the strait and laid out the town of Valona to provide houses and other services to the railroad men, stevedores, mill workers, and sailors that came to work on the bustling waterfront.

Farther west, Prentis Selby began constructing his smelter in 1883 on land he purchased from Patrick Tormey. Selby Smelting and Lead began operations in 1885. Like every other businessman at the time, Selby constructed a hotel for his workers and eventually a little village sprang up near the smelter. The smelter went out of business in 1970 and scarcely a trace remains today of the town and the once powerful business.

About a mile west of Selby was the Union Oil Refinery with its little village called Oleum. The village is long gone, but the greatly expanded refinery still is in operation, having undergone several changes in ownership over the years.

The boom years of the strait are gone. Only Port Costa remains as an independent community. Indeed, the southern portion of town looks much as it did when G.W. McNear ran things. Crockett has continued to flourish along with the C&H Sugar Refinery that nurtured it. Along the way Crockett had absorbed the communities of Valona and Tormey. Selby and Oleum are defunct. The following pages are a photographic history of the south shore of the Carquinez Strait as it once was.

One
PORT COSTA

Port Costa sits in a little valley that was once part of a 4,000-acre ranch owned by William Piper. In the 1870s the Central Pacific Railroad selected the site to build its transfer terminal. The deep water of the channel and its close proximity to Benicia (the north shore train terminal) made it an ideal crossing point. Since the site was the main port in Contra Costa County the terminal was Port Costa. The ferries began service in 1879. Sensing a good business venture in the making, G.W. McNear built his Port Costa Warehouse and Dock Company in 1880. He eventually bought out William Piper and laid out the town of Port Costa, much of which still exists, in the little "Bull Valley" to the south of the ferry slips.

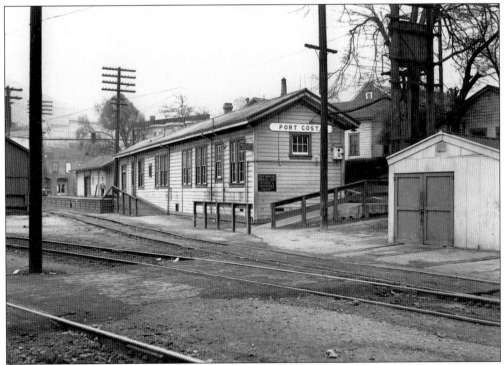

This photo shows the Port Costa Train Depot near the end of its active service, c. 1958. By 1960 the Southern Pacific Railroad had moved all service to Martinez, and the Port Costa depot and yard were closed for good. (Contra Costa Historical Society.)

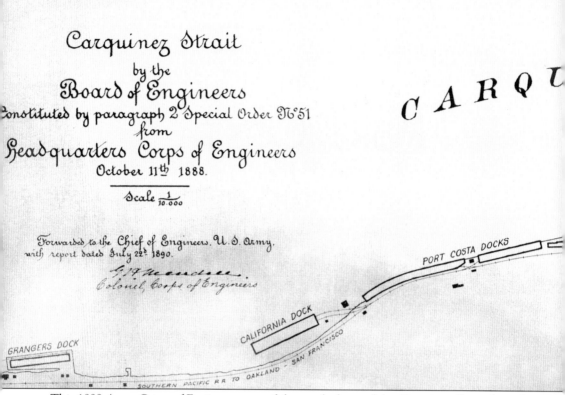

This 1888 Army Corps of Engineers map of the south shore of the Carquinez Strait shows how quickly the area was developed after the Southern Pacific Railroad chose Port Costa as its ferry service transfer port. Granger's Warehouse and Dock, one mile east of Eckley, escaped the fiery fate of the other wharves and warehouses that eventually all burned down. Granger's was finally claimed in the 1920s by the toredo, a pile-boring marine worm. The California Dock near Eckley burned to the water line in 1924. McNear's Port Costa Docks burned in 1889, but were

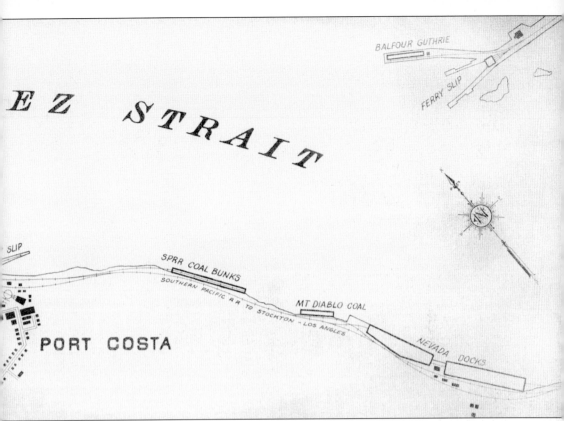

rebuilt and lasted 32 years after G.W. McNear's death in 1909. The Port Costa Docks finally succumbed to a devastating fire in 1941. Old Port Costa was demolished in 1921 when toredo-damaged piles made repair impossible. When the Port Costa ferry slips were dismantled in 1931 the last vestige of Port Costa's waterfront was gone forever. The Nevada Docks, the largest on the strait and farthest west on this map, burned in 1910 and were not rebuilt.

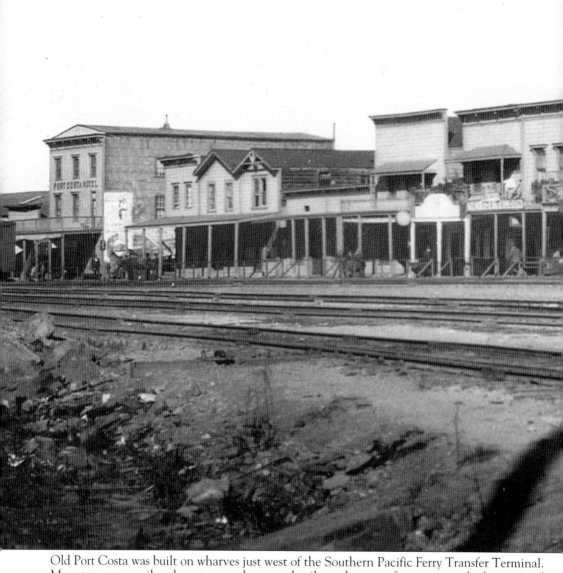

Old Port Costa was built on wharves just west of the Southern Pacific Ferry Transfer Terminal. Meant to serve railroad men, stevedores, and sailors, the waterfront town, which consisted primarily of boarding houses and saloons, was rough. Australian botanist N.A. Cobb made a survey of the California wheat industry in the late 1880s. His description of the south shore of the Carquinez Strait is instructive. Cobb writes: "The towns, or groups of houses, which straggle

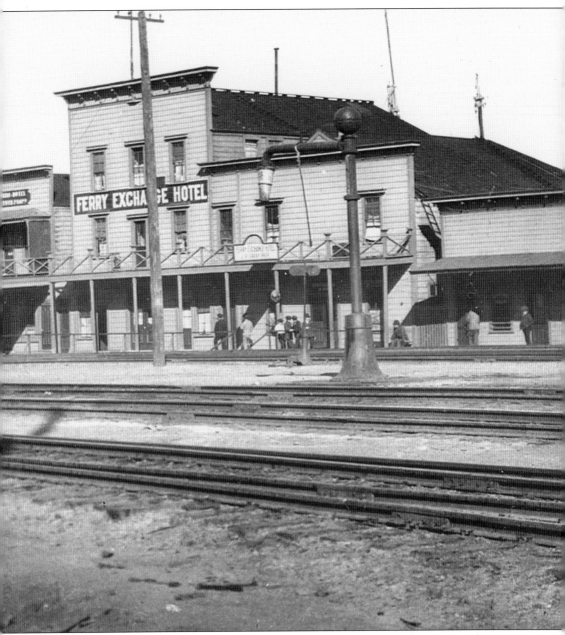

along all the way from Vallejo [Junction] to Martinez, are not up to any description. The main street, along the railroad track, has but one side; each house has but one sign upon it, and that is always 'saloon.' " Old Port Costa survived various fires and the 1906 San Francisco earthquake before finally succumbing to the toredo pile worms. The waterfront section of Port Costa was demolished in 1921.

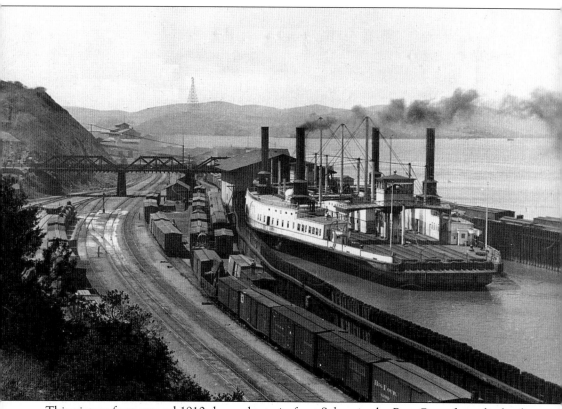

This picture from around 1910 shows the train ferry *Solano* in the Port Costa ferry slip loading for the return trip to Benicia. In its day, the *Solano* was the largest ferry in the world. The *Solano*, along with its sister ship, the *Contra Costa*, built in 1914, plied the waters between Benicia and Port Costa for 50 years and were a vital link in the transcontinental train service.

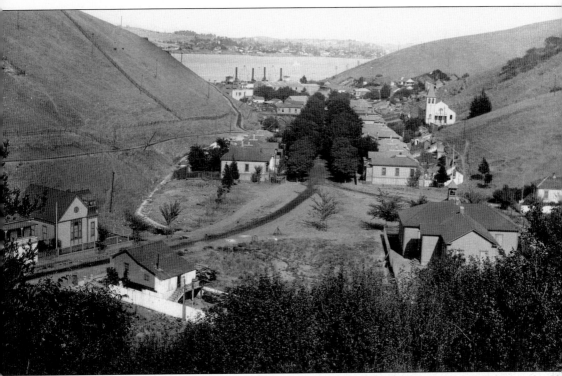

This picture shows Port Costa looking north from the south end of town around 1909. The little schoolhouse in the right foreground was replaced by a larger brick structure in 1911. Note Saint Patrick's Church (middle right) and the smokestacks of the *Solano* visible in the distance.

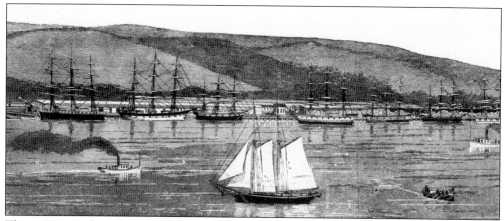

This *c.* 1900 etching depicts the busy south shore of the Carquinez Strait between Port Costa and Crockett. These dock and warehouses were used to store the grain brought in on barges and boxcars as well as to load the grain ships that transported Port Costa grain around the world.

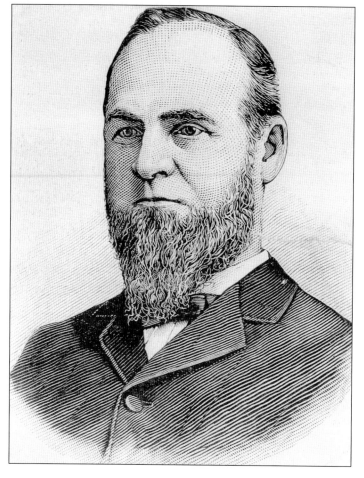

George Washington (G.W.) McNear was known locally as the "Grain King." He controlled much of the wheat exported from California to Europe, where he had offices in London and Liverpool. His Port Costa warehouses and docks were his largest and most profitable holdings. In 1897 McNear bought the Starr Mill in Crockett and tried his hand at milling flour but quickly switched to sugar beet refining. In 1906 Hawaiian interests bought the refinery and began processing sugar cane.

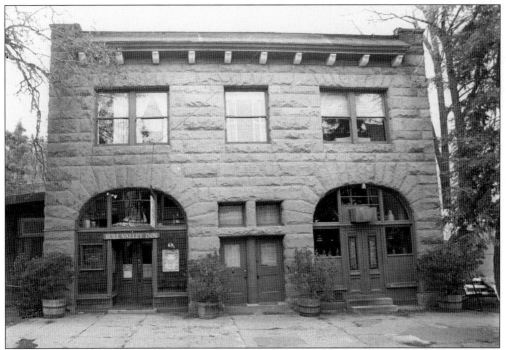

G.W. McNear's building on Canyon Lake Drive was constructed in 1897 to serve as offices for his grain interests and water company. The building now hosts a popular restaurant called the Bull Valley Inn.

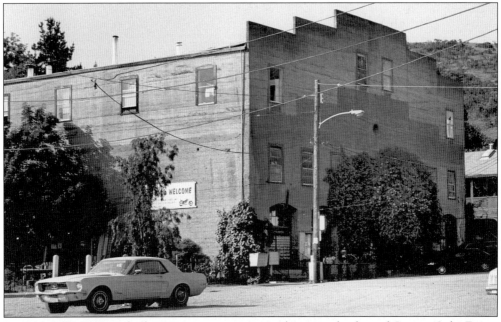

In 1886 G.W. McNear built a two-story cement warehouse at the foot of Canyon Lake Drive. It was the first fireproof building in Contra Costa County. After the 1906 earthquake, a third story was added to the warehouse to be use for storage space. The warehouse is still in use today as a restaurant on the ground floor and apartments on the third floor.

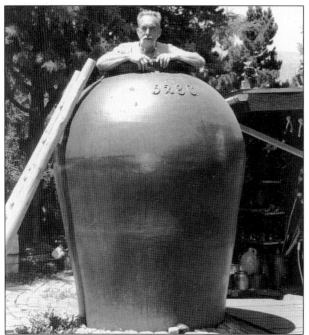

Artist Clayton Bailey, a 30-year Port Costa resident, is widely known for both his metal and ceramic sculptures. Here Bailey poses inside a ceramic pot he salvaged from the old Hercules Dynamite Plant. In 2000 the John Natsoulas Press published a book about his work titled *Happenings in the Circus of Life*.

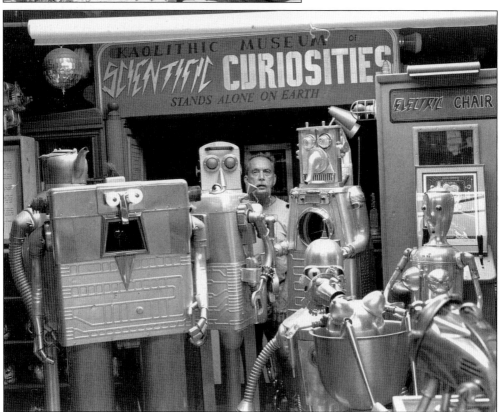

Bailey poses among a few of the metal sculptures he is famous for building in his Port Costa studio.

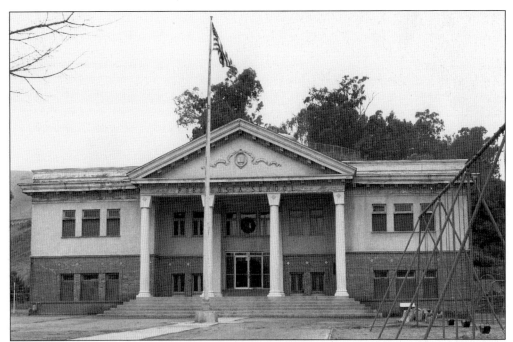

This two-room schoolhouse was built in 1911 and served the people of Port Costa for 55 years before being closed in 1966. Since that time the school has been use as a town meeting hall and to provide summer programs for kids.

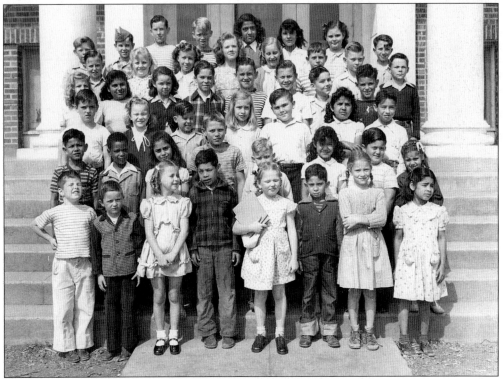

The student body poses on the front steps of the Port Costa school, c. 1947.

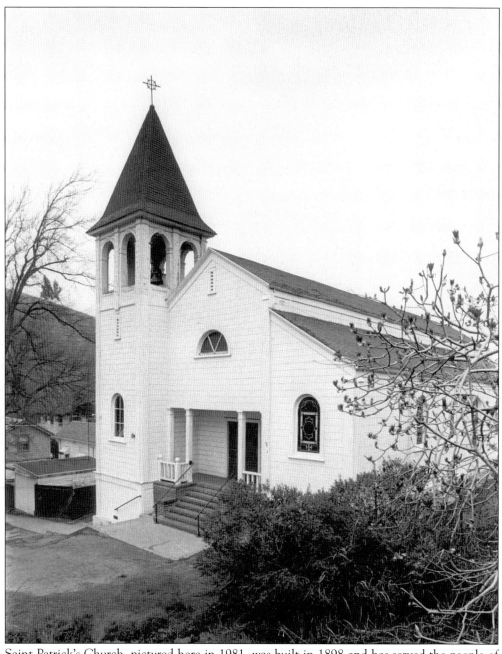
Saint Patrick's Church, pictured here in 1981, was built in 1898 and has served the people of Port Costa for 106 years.

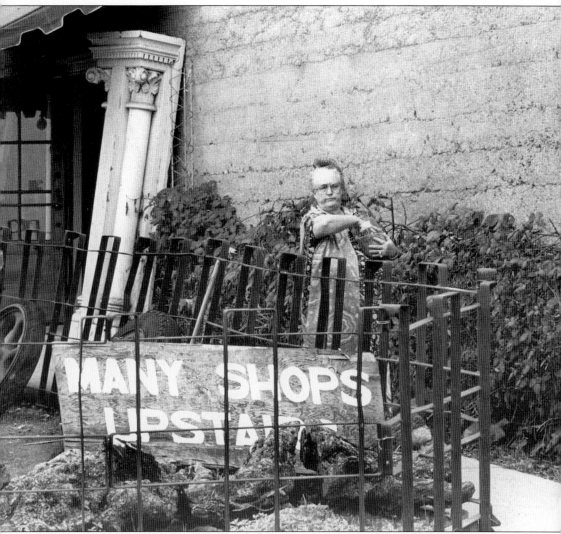

Eccentric restaurateur Juanita Musson came to town in 1976 to manage the Warehouse Café. She had a loyal clientele who delighted in her antic behavior; her motto was, "Eat it or wear it." In 1990 writer Sally Hayton-Keeva published Juanita's story in a book titled *Juanita: The Madcap Adventures of a Legendary Restaurateur*.

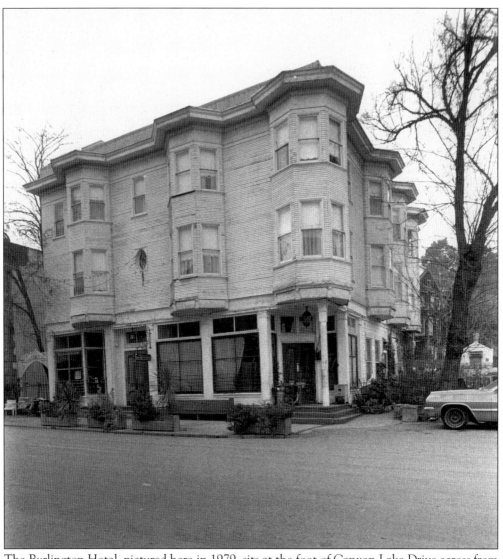

The Burlington Hotel, pictured here in 1979, sits at the foot of Canyon Lake Drive across from McNear's old warehouse in Port Costa and is, like every other structure downtown, over 100 years old.

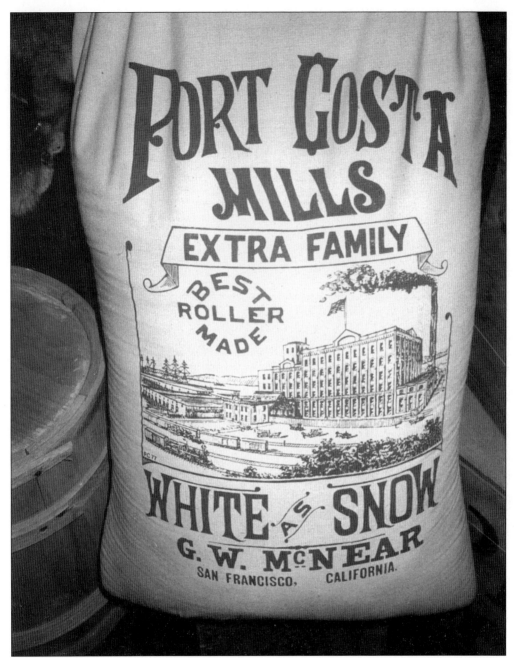

One flour bag from McNear's Port Costa Mills has managed to survive until today. The bag bears a nice depiction of the early refinery.

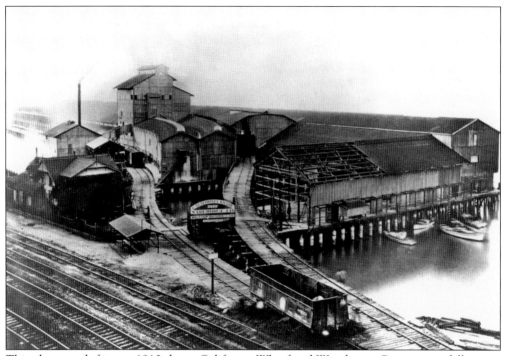
This photograph from *c.* 1910 shows California Wharf and Warehouse Company in full swing.

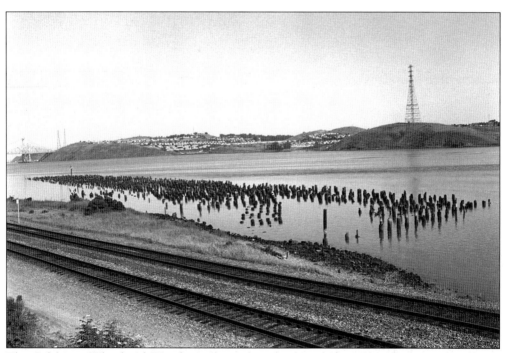
The California Wharf and Warehouse burned to the waterline in 1924 and was not rebuilt. Today only the dilapidated piles leave a footprint of the busy wharves' former life.

Two
ECKLEY

In 1870 John Eckley (1827–1898) purchased from William Piper about 350 acres of land in a little cove between Port Costa and Crockett. He quickly built a home and pier for his racing yacht *Emerald*. John Eckley was an avid sportsman and sailor who, along with his partner, Matthew Turner, owned a successful boat building business in Benicia.

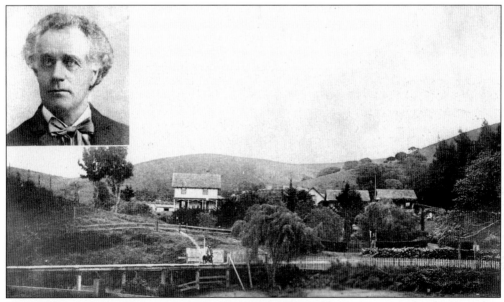

John Eckley is pictured here in a penny postcard from *c.* 1900.

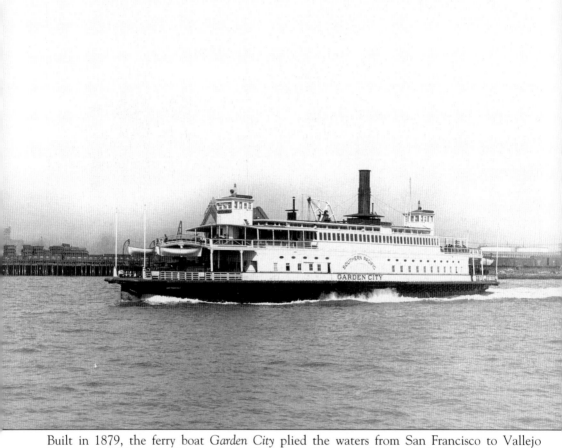

Built in 1879, the ferry boat *Garden City* plied the waters from San Francisco to Vallejo Junction for 50 years. The opening of the first Carquinez Bridge in 1927 and the rise in popularity of the automobile put an end to the ferry service on the Carquinez Strait. The *Garden City* was retired from service in 1929 and sat idle near the west end of the C&H Sugar Refinery docks for several years. In 1936 the ferry was purchased by Martin Hallissy and towed to the pier at Eckley, where she was remodeled to serve as a dance hall, dining room, and bar for local functions. That lasted until the 1950s when she was abandoned in place and left to slowly deteriorate. The end came in 1983 when the *Garden City* and Eckley's few remaining homes were destroyed in a fire that ravaged the hills between Crockett and Port Costa. (Contra Costa Historical Society.)

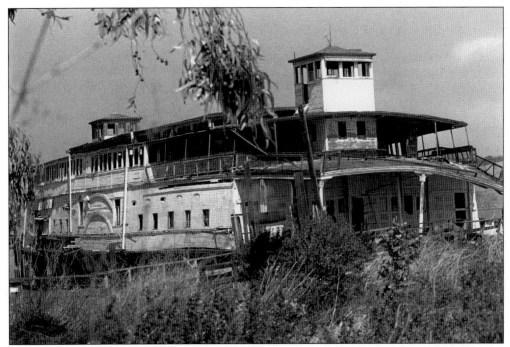

By 1981 the once stately *Garden City* was collapsing into the bay. The old ferry was little more than a curiosity for people walking along the shore.

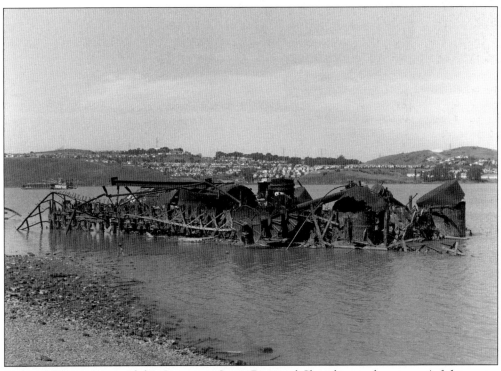

Today Eckley is a part of the Carquinez Strait Regional Shoreline park system. A fishing pier runs next to the rusting remains of the *Garden City*.

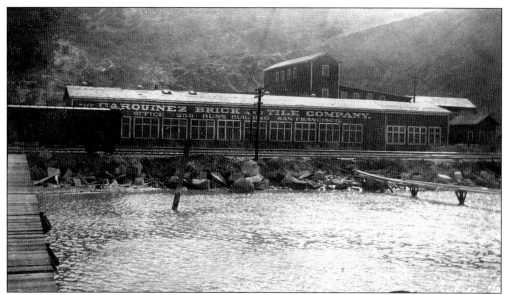

The Carquinez Brick and Tile Company, shown here c.1915, occupied a patch of the shoreline between Eckley and Crockett.

This photograph from 1920 shows the east end of Granger's Warehouse collapsing into the bay due to toredo-damaged piles. The toredo did as much damage to waterfront business as fire ever did. Some businesses replaced damaged wooden pile with toredo-proof cement piles. Other businesses simply ceased operations and their wharves and warehouses were dismantled or burned.

Three
CROCKETT

The town of Crockett is the most successful of the communities that sprang up along the south shore of the Carquinez Strait in the 1880s. The deep waters of the Carquinez Strait, combined with the railroad's heavy traffic along the strait, made Crockett an ideal location to start a business. Abraham Starr built his Starr Mill in Crockett for just these reasons. Starr's mill still exists as the eastern portion of the C&H Sugar Refinery. Crockett owes much of its success to the C&H Sugar Refinery for providing jobs and numerous forms of community support over the ensuing years.

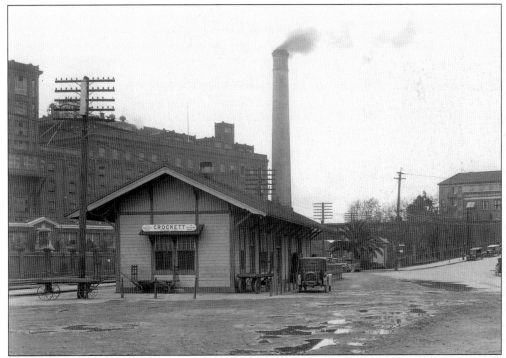

Shown here is a photograph of Crockett Depot, c. 1920.

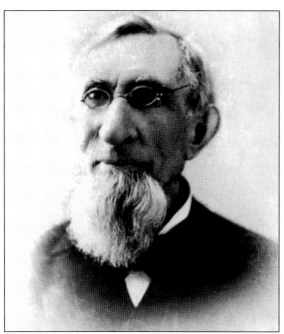

Born in Kentucky, Judge Joseph Bryant Crockett (1808–1884) was educated as a lawyer and served in the Kentucky House of Representatives before beginning his journey west at age 44. In 1853 Crockett arrived in San Francisco where he worked helping establish legal title for the owners of the Spanish land grants. In 1865 Crockett accepted an 1,800-acre parcel of land on the Carquinez Strait as payment for such legal services. Just two years later Crockett was appointed to the California Supreme Court.

> **HISTORY.** Over fifty years ago, my father, the late THOMAS EDWARDS Jr told me he was 16 years old when the family moved into this area in 1866 now known as "CROCKETT." LAWYER JOSEPH CROCKETT won a law suit and took as payment an area of uninhabited land on the banks of CARQUINEZ STRAITS. Now LAWYER JOSEPH CROCKETT and TOM EDWARDS Sr were old time friends from back in INDEPENDENCE, Mo. and both moved to CALIFORNIA in the early '60s. JOSEPH CROCKETT located the EDWARDS family near STOCKTON and persuaded TOM EDWARDS to locate on this newly acquired land situated on the banks of CARQUINEZ STRAITS.
>
> LAWYER CROCKETT wanted to name this area "EDWARDSVILLE" but THOMAS EDWARDS Jr objected, and said "He would name it after his old friend CROCKETT." That is how the town got its name of CROCKETT! JOSEPH CROCKETT became a successful lawyer, and later a well known judge in California. At the time of his death he was a member of the CALIFORNIA STATE SUPREME COURT.
>
> Edith Edwards Dyer

In 1976 Edith Edwards Dyer, the granddaughter of Thomas Edwards, wrote this account of how Crockett got its name.

Thomas Edwards (1812–1883), an old friend of Joseph Crockett, was brought in to work Crockett's parcel of land and protect it from squatters. In 1868 Edwards built a house for his family, cleared the land and began planting crops and tending cattle.

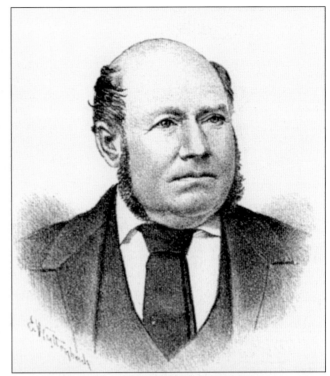

Crockett's founding family, pictured here in 1903, from left to right, are (seated) Ed Edwards, mother Mary Edwards, and John Edwards; (standing) Hugh Edwards, David Edwards, and Thomas Edwards. Mrs. Edwards (1819–1905) was 83 years old when this photograph was taken.

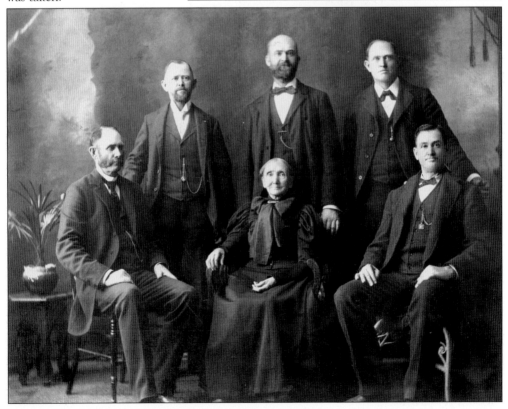

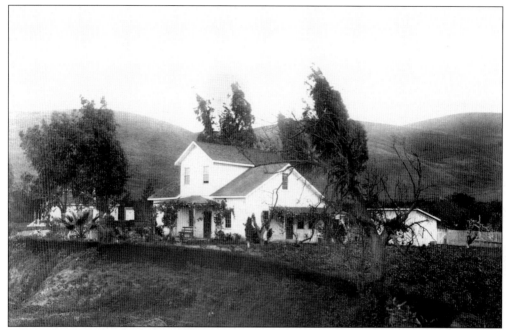

This undated photo shows the Old Homestead built by Thomas Edwards Sr. sometime in 1867. The bluff in the foreground is the original shoreline of the Carquinez Strait. The eucalyptus trees were a gift of John Eckley.

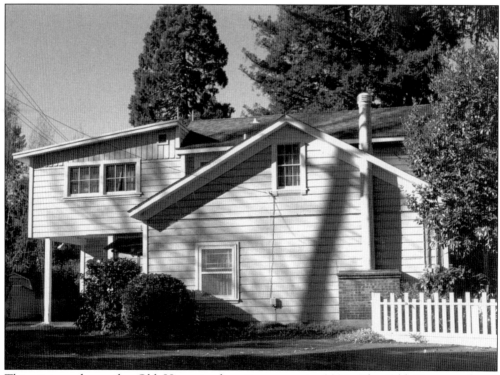

This picture shows the Old Homestead as it appears in 2004. The Old Homestead was designated California Historical Landmark No. 731 in 1960.

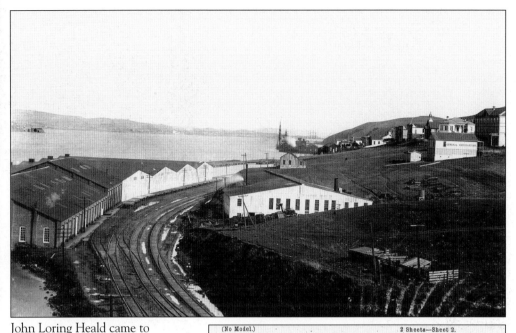

John Loring Heald came to Crockett in 1880 and helped Tom Edwards lay out the town. Heald was able to obtain a franchise for some waterfront property, where he built a foundry (pictured center) and a dock. Heald's foundry produced a wide variety of agricultural equipment. After his death, Valley Street was changed to Loring Street in his honor. In 1949 the *Crockett American* reported that efforts were afoot to obtain a photograph of John Heald for the state's centennial celebration. It is unclear whether a photograph of Heald was ever found. (Contra Costa Historical Society.)

This image shows the detail from one of the many successful patents awarded to J.L. Heald for one of his agricultural machines.

33

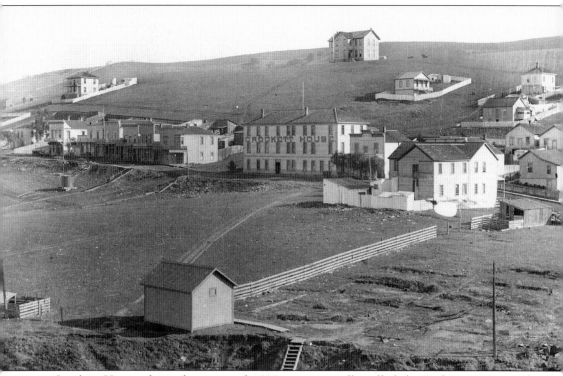

Crockett House, shown here around 1890, was originally called the Pinkerton House when Heald built it in 1882 to house the workers at his foundry. The building stood for more than 100 years at 707 Loring Street at the corner of Bay Street until it was demolished in the late 1990s.

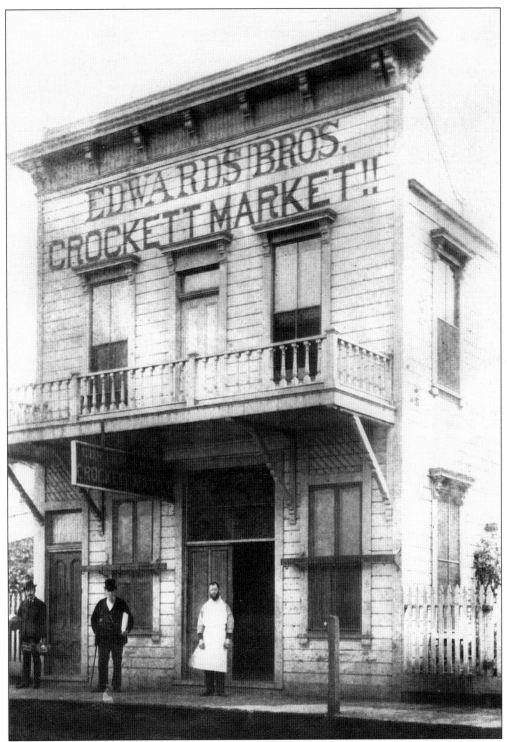
The Edward Brothers Crockett Market, shown here, burned along with several other buildings in the fire of 1890.

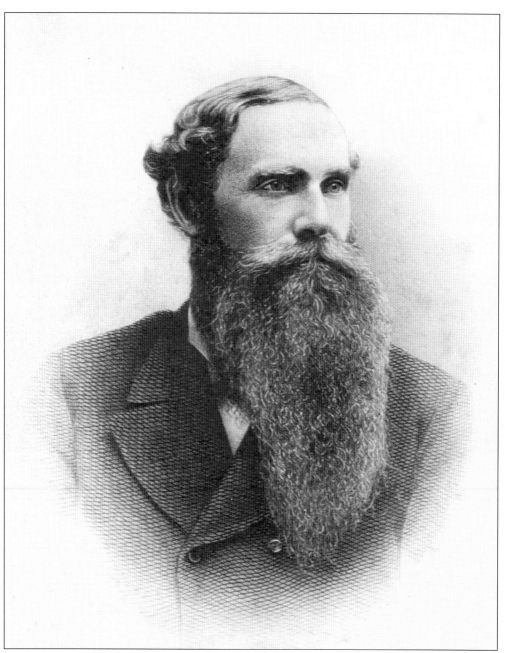

Abraham Starr (1830–1894) came to California seeking his fortune during the Gold Rush when he was just 18 years old. He already owned a flourmill in Vallejo when he bought the property where the C&H Sugar Refinery now stands. When Starr finished his building it was considered one of the finest mills in the world. However, his mill never got into heavy production and he went broke in the bank panic of 1893. G.W. McNear bought the mill and eventually converted it to a beet sugar refinery before selling to Hawaiian interests who formed the C&H Sugar Refinery in 1906. The history of Crockett would probably be very different had Abraham Starr not built the Starr Mill. In many important ways Crockett owes its very existence to Abraham Starr and his mill.

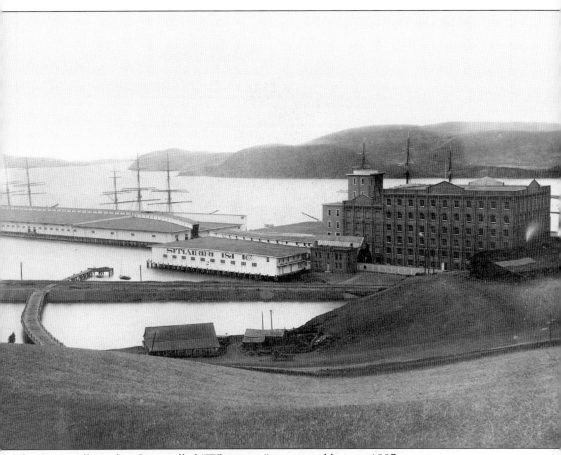

The Starr Mill in what Starr called "Wheatport" is pictured here c. 1887.

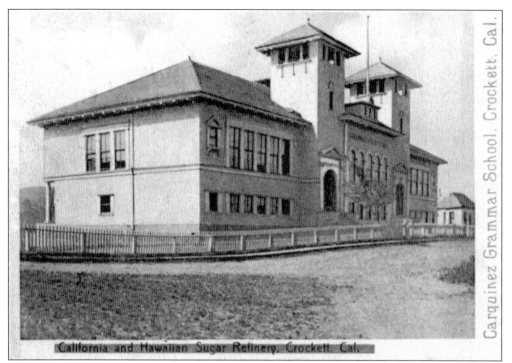

In 1907 C&H Sugar Refinery produced a series of penny postcards like this one depicting the original Carquinez Grammar School on Alexander Street overlooking the C&H. The school remained in service until 1923 when the new Carquinez Grammar School opened on Pomona Street between Crockett and Valona—an area of town that has long been known as "Crolona." This old building is still standing as apartments.

About one-third of the old grammar school still survives as an apartment building on Alhambra Street.

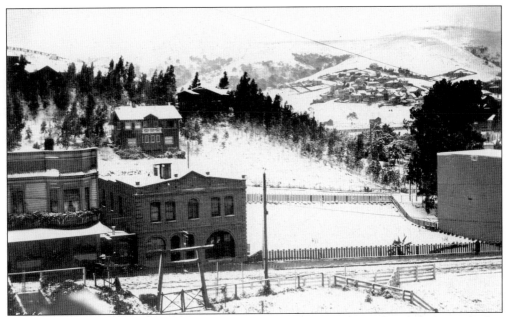

This photo from January 1913 shows a snow-covered Park View Hotel and the grounds that would become Rithet Park. The Park View Hotel was torn down in the early 1990s, and Rithet Park was restored and expanded to include bocce-ball courts.

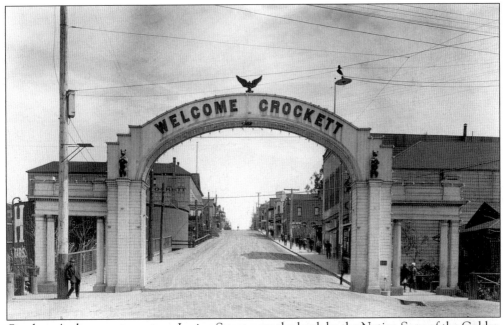

Crockett Arch was put up across Loring Street near the bank by the Native Sons of the Golden West in 1913. In 1916 the old bank building, pictured on the lower right, was moved to its current location across from the Crockett Historical Museum and now serves as the town library. The arch was removed in 1923 when Loring Street was widened and paved.

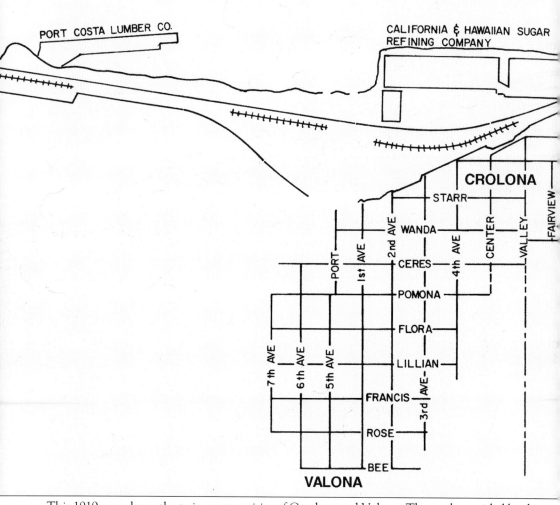

This 1919 map shows the twin communities of Crockett and Valona. The work provided by the

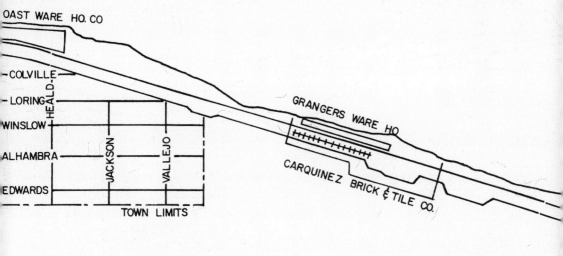

CROCKETT TOWN MAP
1919

C&H Sugar Refinery is largely responsible for the community's growth and development.

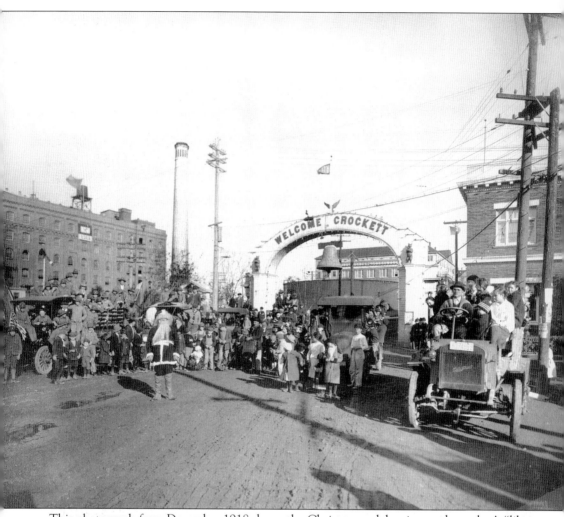

This photograph from December 1918 shows the Christmas celebration at the arch. A "liberty bell" was hung from the arch in support of troops fighting in World War I. Local children were given rides in the trucks pictured. The children in the center seem more interested in the organ grinder and his monkey than they are in Santa Claus or the trucks.

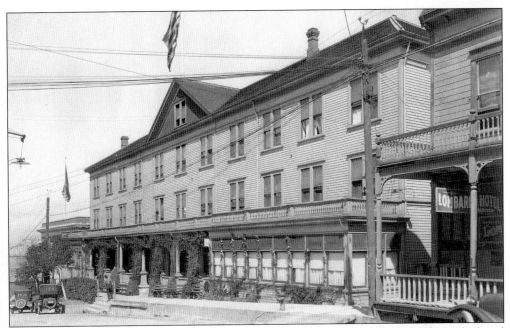

The Hotel Crockett, with 104 rooms and electric lights, opened September 25, 1898. The hotel stood east of the C&H Sugar Refinery main entrance on Loring Street for 42 years (where the C&H parking lot is now). The landmark hotel was torn down in August and September of 1940. The hotel is seen here decorated for the Fourth of July, 1923.

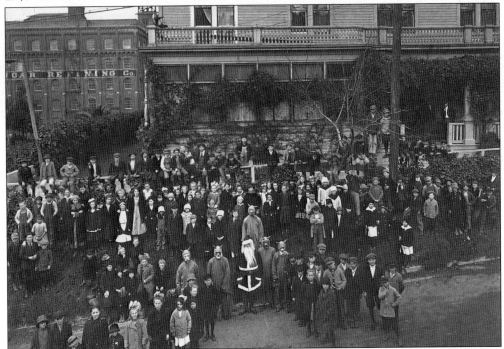

A group of Christmas revelers pose with Santa Claus in front of the Hotel Crockett in December of 1916. The menacing figures around Santa look like devils but they are supposed to be his reindeer.

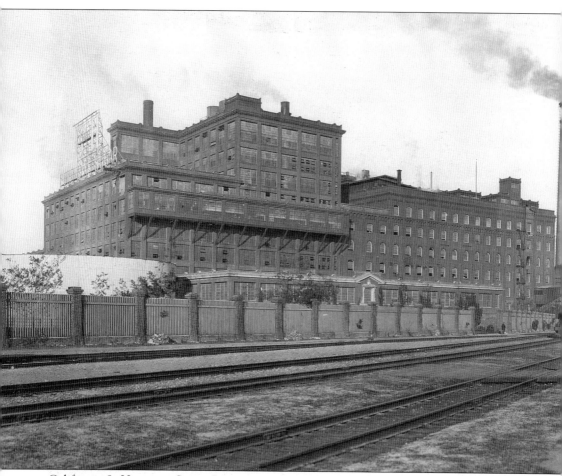

California & Hawaiian Sugar Company, pictured here in 1921, started operations in March 1906. Abraham Starr built the six-story eastern portion of the factory in the late 19th century. Starr operated it as the Starr Mill until he went broke in the bank panic of 1893. The refinery passed through the hands of George W. McNear before becoming the C&H we know today.

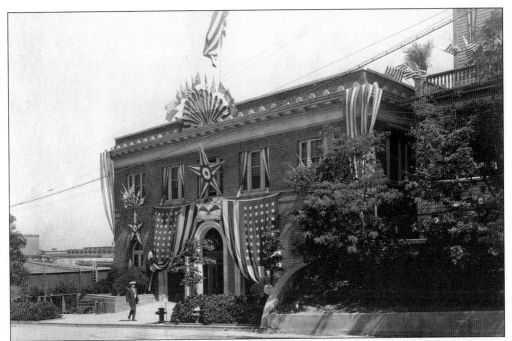

The office and main entrance of the C&H Sugar Refinery is shown here decked out for the Fourth of July, 1923.

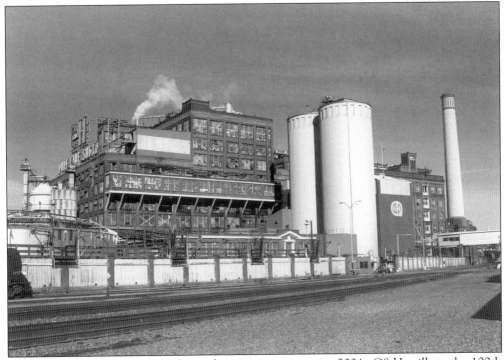

The C&H Sugar Refinery is shown here as it appears in 2004. C&H will marks 100th anniversary in Crockett in 2006.

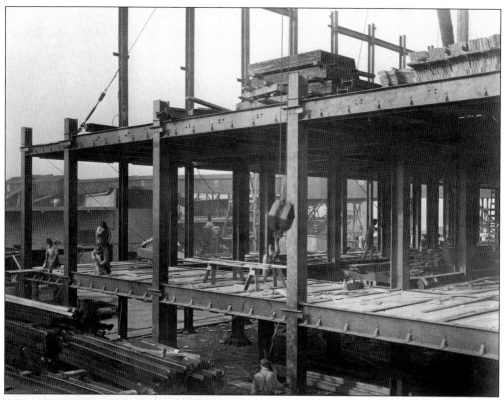

This picture from c. 1919 shows the expansion of the C&H Sugar Refinery. The plant has been in operation almost around the clock for 98 years and has undergone many expansions and retrofits in that time.

For many years the C&H publication *Cubelet Press* carried company and town news to C&H employees and their families. This issue from 1987 documents the contribution that pile drivers have made in the construction and maintenance of the refinery.

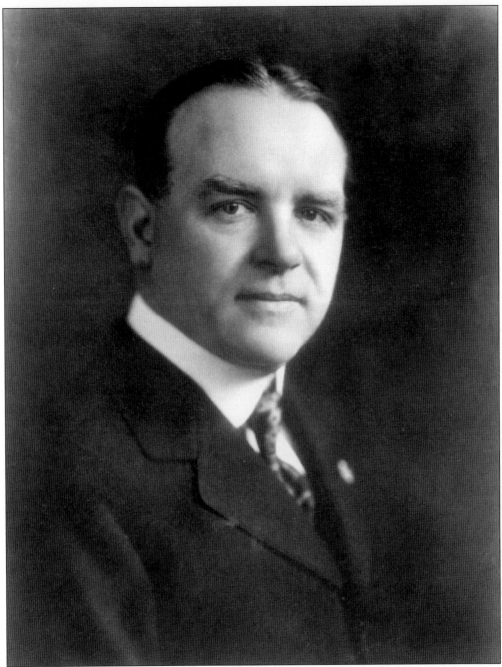

George Morrison Rolph (1873–1937) was the first plant manager of the C&H Sugar Refinery and one of Crockett's chief benefactors for over 20 years. Among the many accomplishments of Rolph's tenure in Crockett were the construction of the Hotel Crockett, the 1914 reduction of the workday from 12 hours to 8 hours a day, construction of the Crockett Club, the Crockett Community Auditorium, and Alexander Park. Rolph also opened company land for housing developments, such as Tenney Terrace, which the C&H helped finance for its employees.

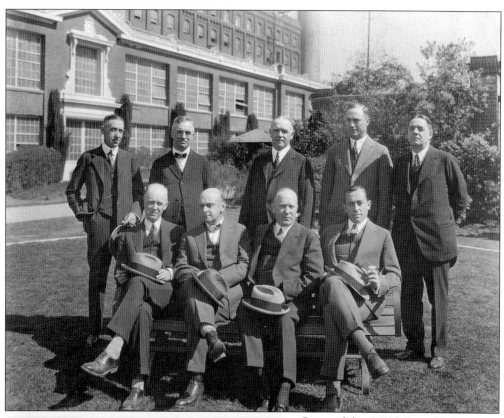

Some of the C&H Sugar Refinery directors pose for a picture in March 1926 as part of the 20th anniversary ceremonies. Pictured, from left to right, are (front row) Charles V. Bennett, Pierce A. Drew, William F. Sampson, and George G. Montgomery; (back row) Charles H. Fairar, Ronald T. Rolph, George M. Rolph, Louis Camiglia, and Alphonse M. Duperu.

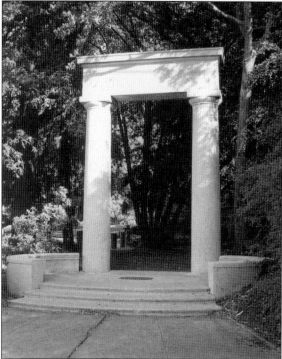

A monument dedicated to the memory of George Morrison Rolph sits at the foot of Rolph Park Drive and Pomona Street. Because of its neoclassical design, some locals affectionately refer to this spot as "Rome."

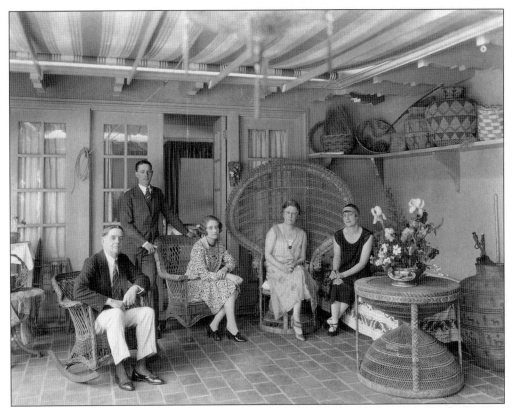

One of the C&H Sugar Refinery directors, Alphonse Duperu, (seated left) is shown with his family in 1926. Duperu was one of several C&H managers who had a street named in his honor.

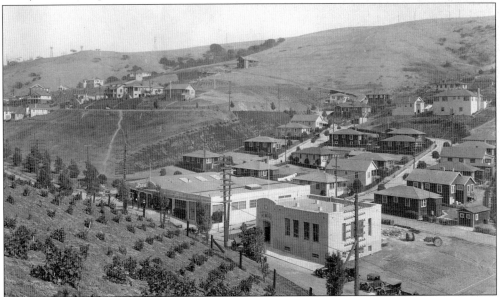

The housing development of Tenney Terrace, named for C&H Sugar Refinery executive Vernon Tenney, was an attempt by C&H to curb the housing shortage for its workers. The company developed the land and helped workers finance the purchase of the homes, c. 1925.

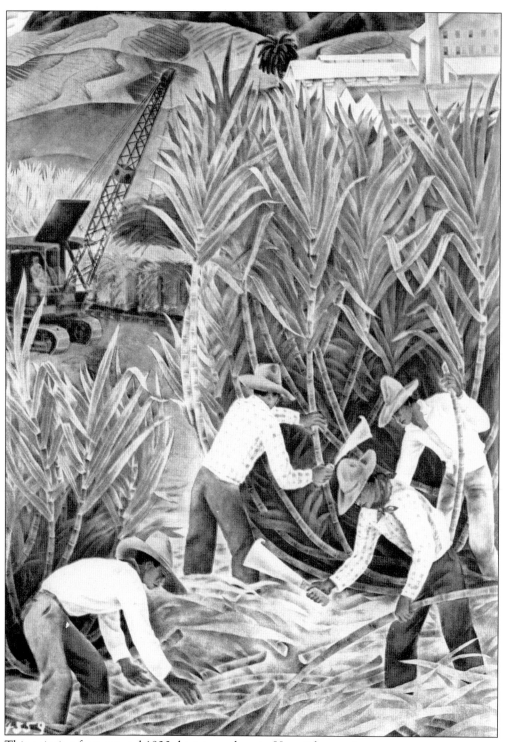
This painting from around 1920 depicts workers in Hawaii harvesting sugar cane.

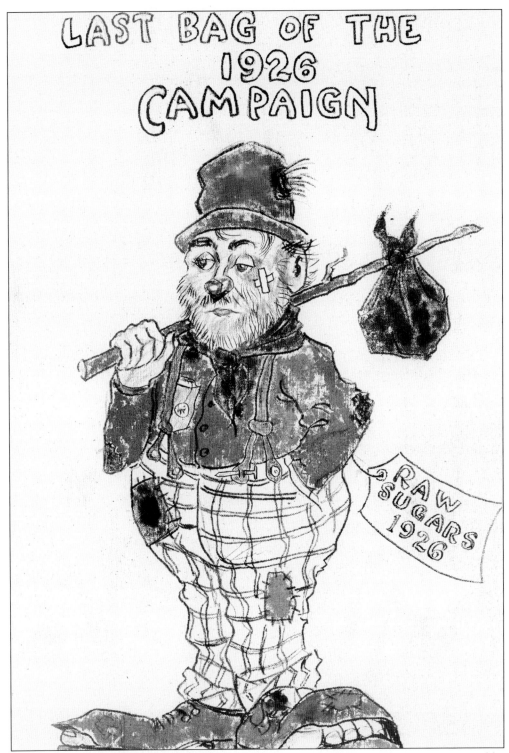

This photo captures a humorous drawing someone made on the last bag of sugar processed by the C&H Sugar Refinery in 1926.

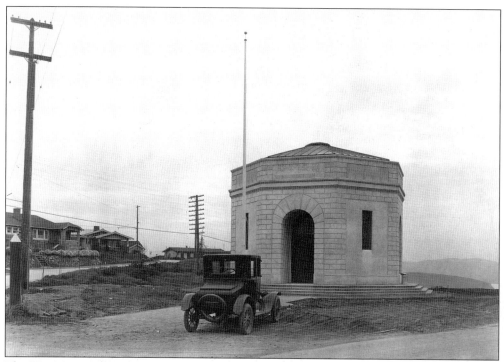
The War Memorial was built on Crockett Heights in 1920 to honor the veterans of World War I.

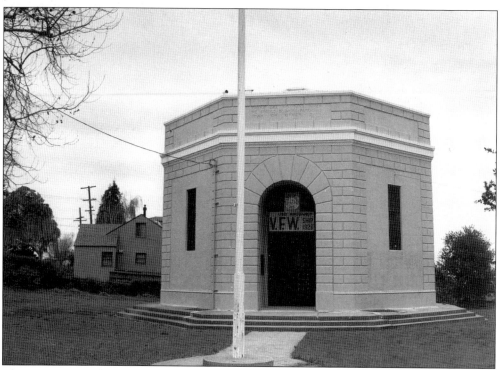
The War Memorial is shown in this picture as it appears in 2004.

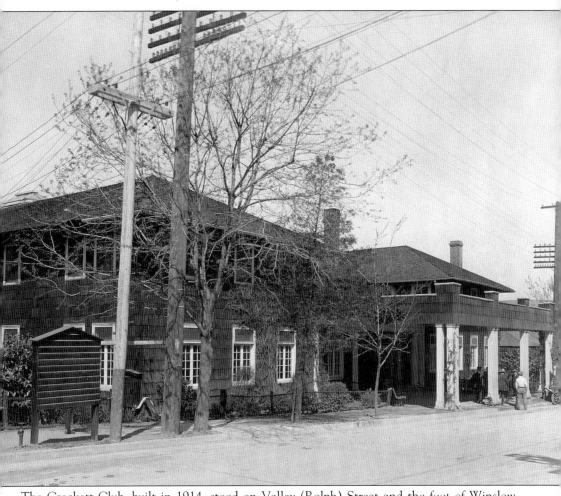

The Crockett Club, built in 1914, stood on Valley (Rolph) Street and the foot of Winslow Street near the current post office. The club had a swimming pool, a billiard room, a reading room, a gymnasium, and a spacious lobby. The Crockett Club was the site of many dances and other social and civic functions for many years. It was torn down in September 1966.

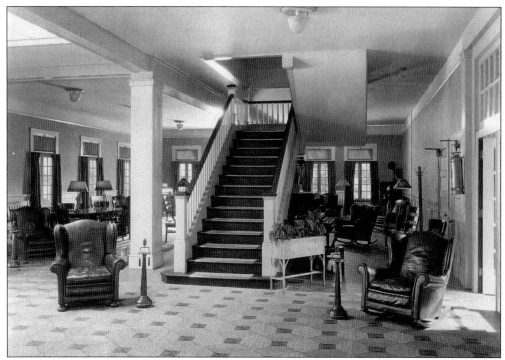

This photo shows an interior shot of the Crockett Club's spacious and comfortable lobby as it appeared in the 1920s.

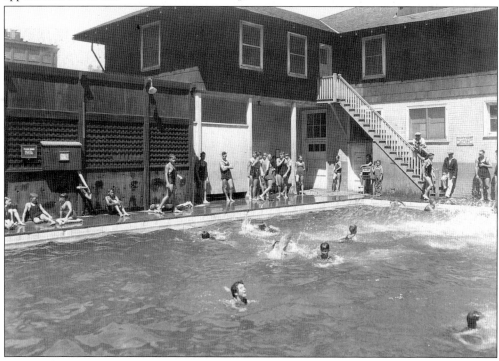

Among the many amenities of the Crockett Club was the swimming pool, which is being put to good use by local children in this photograph, c. 1922.

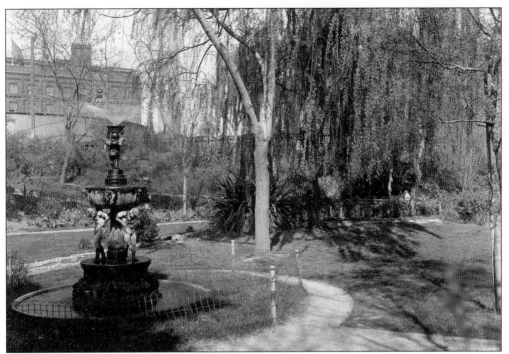

This photograph shows Rithet Park on Loring Street across from the C&H Sugar Refinery as it appeared in 1921. For many years the C&H kept several gardeners on the payroll to maintain the public parks. Rithet Park fell into disrepair in the 1970s but was revitalized in the 1990s and expanded to include bocce-ball courts.

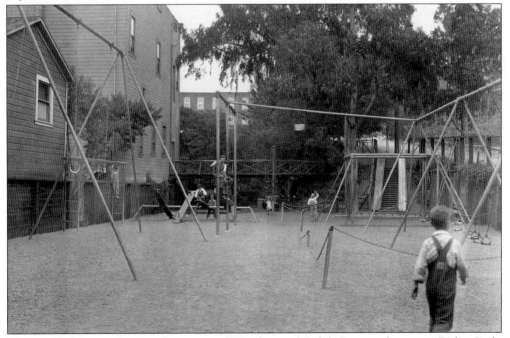

This small playground sat on the corner of Winslow and Rolph Streets adjacent to Rithet Park, c. 1923.

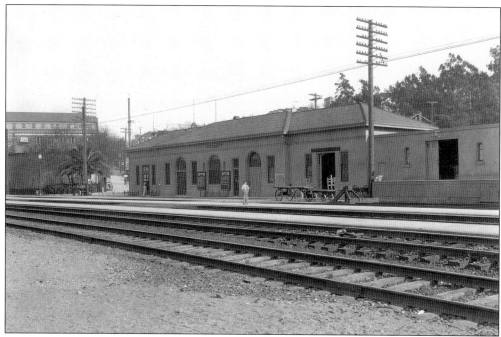

The Crockett railroad depot is shown as it appeared in 1930. Today the building houses the Crockett Historical Museum.

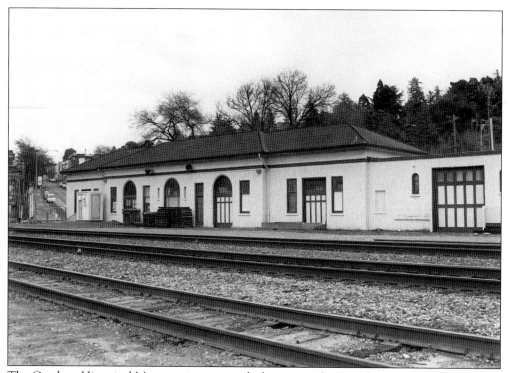

The Crockett Historical Museum appears much the same today as it did when the building was a bustling train station.

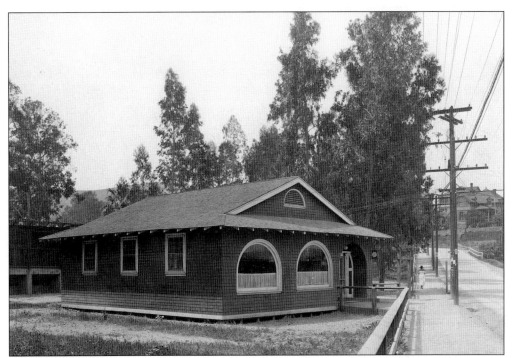

The Crockett Library, pictured here in 1920, was originally the Bank of Pinole when it sat at the corner of Loring and Rolph Streets. It was moved to its current location across from the Crockett Historical Museum in 1916.

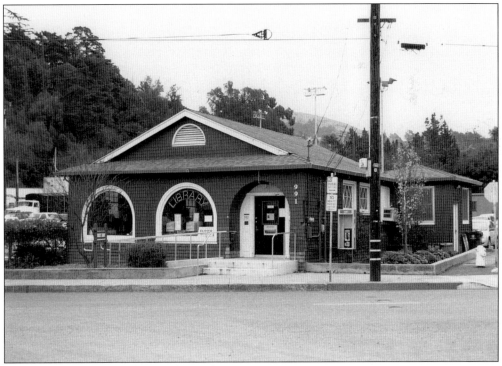

This photograph shows the Crockett Library as it appears in 2004.

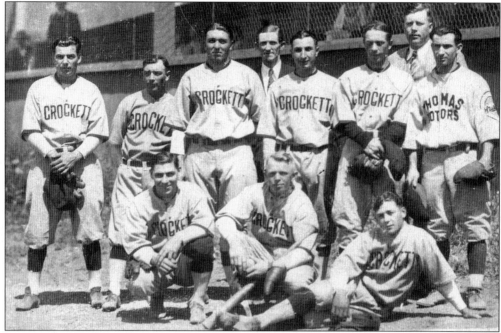

This group of athletes from 1930 represented Crockett in the Inter-Refinery League, which consisted of teams from Union Oil, Shell Oil, Assco Oil, and C&H Sugar. Pictured, from left to right, are (front row) Al Geminani, Al Giesler, and Leo Ougwarsky; (back row) George Velkonia, Pete Kelleher, Chick Bottarini, Preston Moses (team manager), Steve Smacker, Leo Stanley, Andy Andrewsen, and Guy Figueiredo.

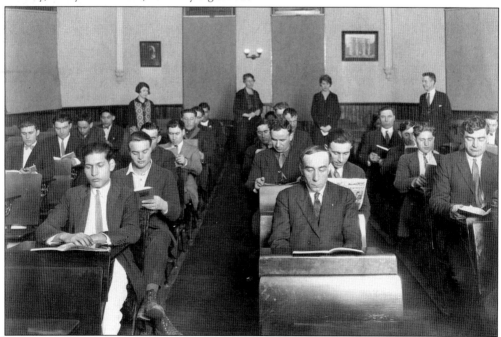

So many immigrants came to Crockett seeking work in the refinery that the C&H sponsored English language classes for its employees. The class pictured here is from c. 1925.

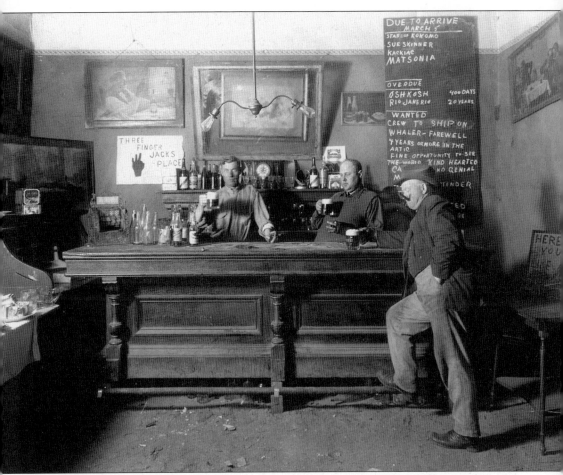

This picture from 1921 entitled "Boucke's—An Oasis in Crockett" was taken one year into Prohibition. Alfred Boucke lived in the Old Homestead and this picture was no doubt taken there. Whether they are flaunting the Prohibition law or this is just a spoof is unclear. Perhaps it's a bit of both.

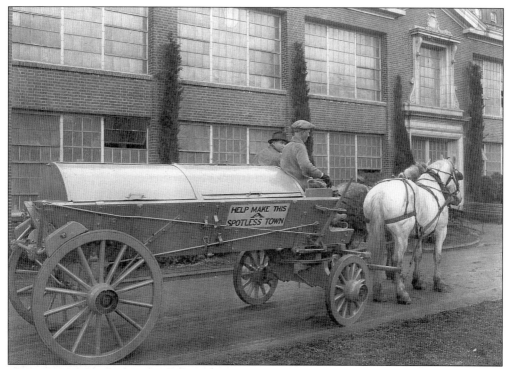

This picture from 1925 shows a horse-drawn cart being used in the town-wide cleanup. Crockett still holds the town-wide cleanup each spring.

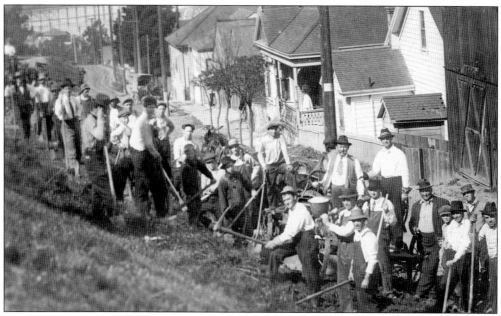

Crockett men work to clear Winslow Street, c. 1920.

Crockett native Aldo Ray, shown here, enjoyed a long career as a television and film actor from the 1950s through the 1980s.

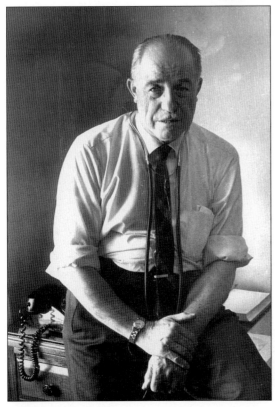

Dr. Sam Eldridge (1903–1972), pictured here in 1967, served as the town doctor for nearly 40 years.

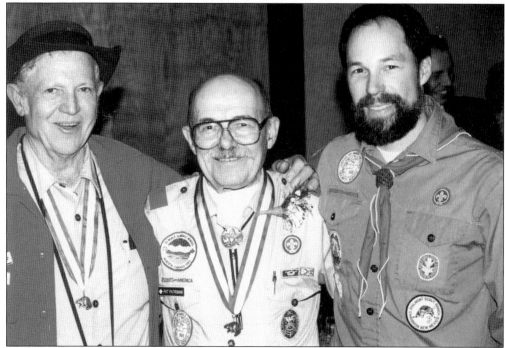

Scouting has a long history in Crockett. Pictured here, from left to right, are Ed Broglio (who has worked with the Boy Scout Troop 171 for over 50 years), Pat Patrignoni (receiving his "silver beaver" award), and Stewart Patrignoni, c. 1994.

Crockett's Boy Scouts are at the back ranch, c. 1925

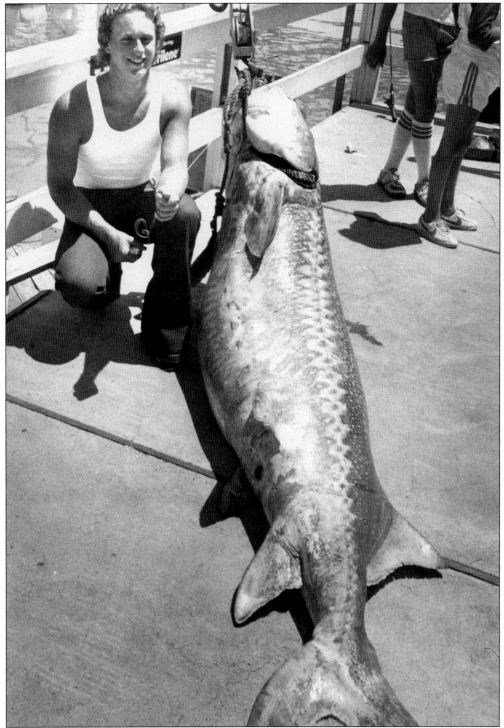

On July 9, 1983 Crockett resident Joey Pallotta hooked this 468-pound white sturgeon in the Carquinez Strait. This fish proved to be a world record catch. The fish is mounted and on display at the Crockett Historical Museum.

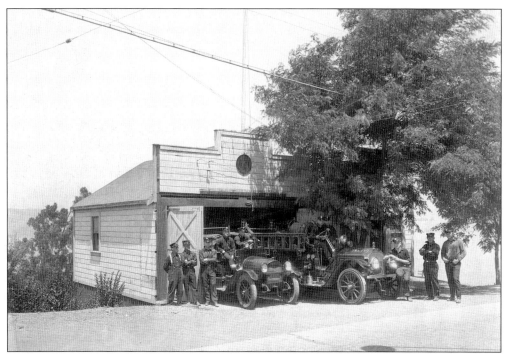

Crockett has always had a well-trained volunteer fire department staffed by civic-minded men and women. This group, from around 1921, poses proudly with their fire trucks.

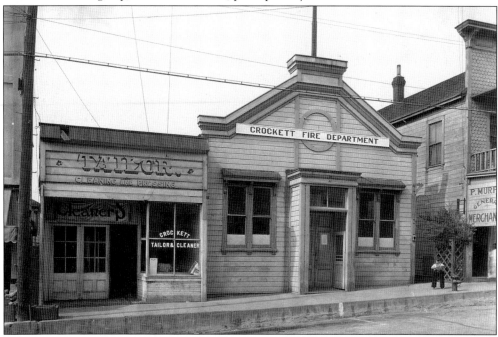

These buildings on Loring Street stood east of the Hotel Crockett very near where the current fire station now stands. The building on the right was long occupied by the Salvation Army. In the early 1920s it was purchased for the Crockett Fire Department. The building was torn down soon after this photograph was taken and replaced with a brick structure built to hold the fire engines.

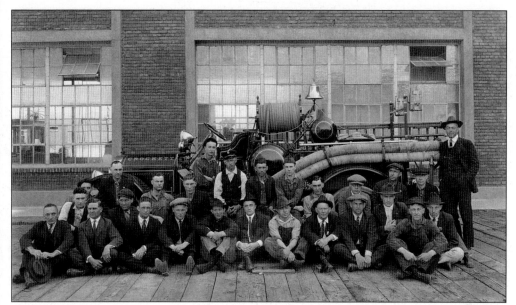

This photograph from 1922 shows a fire crew and their engine at C&H Sugar Refinery. The C&H sponsored its own fire truck and had employees trained as firefighters for quicker response to potential refinery fires.

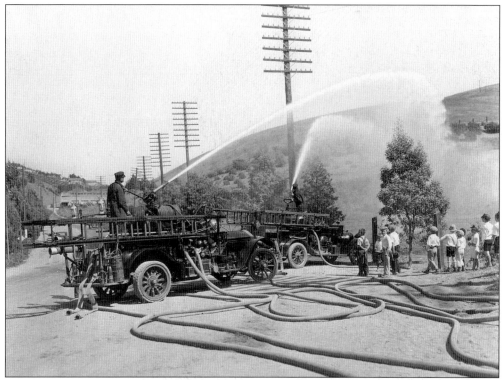

Crockett's volunteer firefighters demonstrate some of their equipment much to the delight of the local children in this c. 1923 photograph.

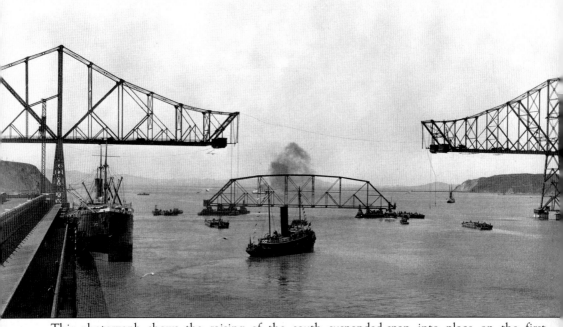
This photograph shows the raising of the south suspended-span into place on the first Carquinez Bridge in March 1927.

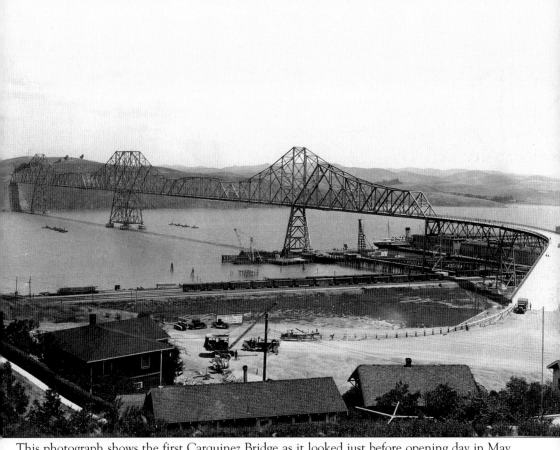

This photograph shows the first Carquinez Bridge as it looked just before opening day in May 1927. The bridge is notable in a number of ways: it was designed by famous bridge engineer D.B. Steinman; it was the longest highway bridge in the world at that time; it was the final link in the Pacific Coast Highway system that linked Canada to Mexico; it was the first major bridge across any part of the San Francisco Bay; and it was where famed bridge man Alfred Zampa started his long career as an ironworker.

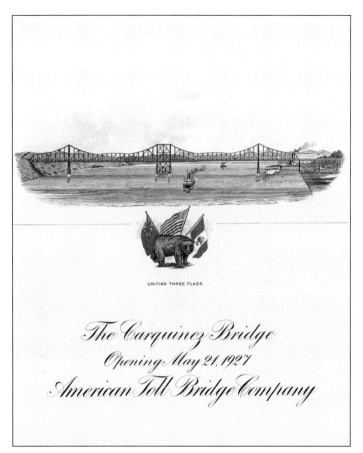

This graphic announces the May 21, 1927 opening of the first Carquinez Bridge. Although an important architectural achievement, the bridge dedication was overshadowed in the news by solo pilot Charles Lindbergh's Paris landing earlier that morning.

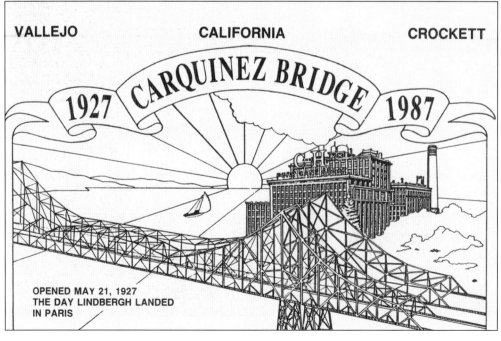

This commemorative card was issued for the 60th anniversary of the first Carquinez Bridge.

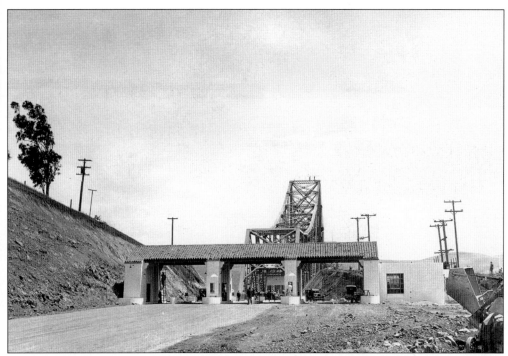

This photograph shows the north approach to the first Carquinez Bridge shortly before opening day in May 1927. At the time the tolls were listed as 60¢ for each car while two-wheeled horse carts were 25¢ and four-wheeled horse carts were 80¢. Horses and cows could be transported across the bridge at 25¢ a head.

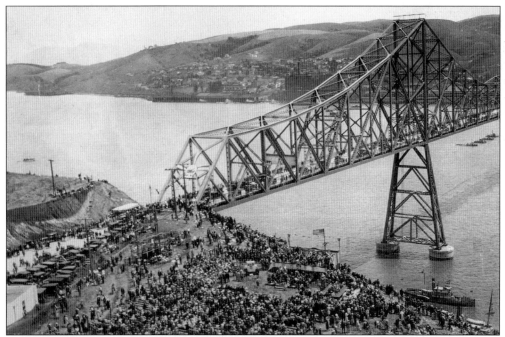

A crowd gathers for the opening of the 1927 bridge.

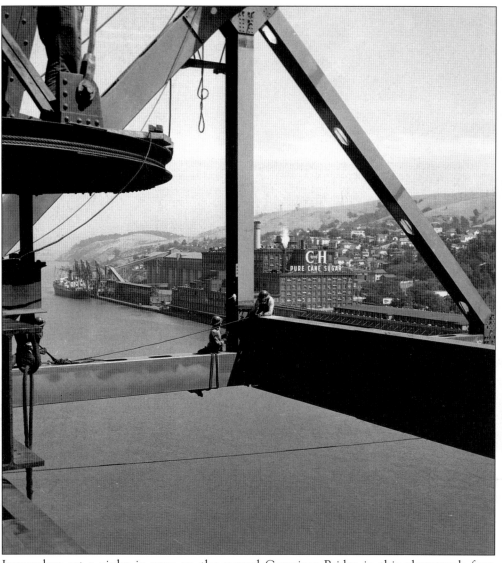
Ironworkers set a girder in pace on the second Carquinez Bridge in this photograph from August 1958.

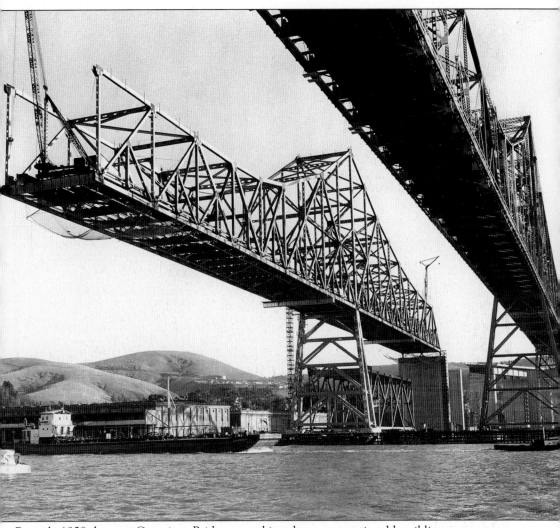
By early 1958 the new Carquinez Bridge was taking shape next to its older sibling.

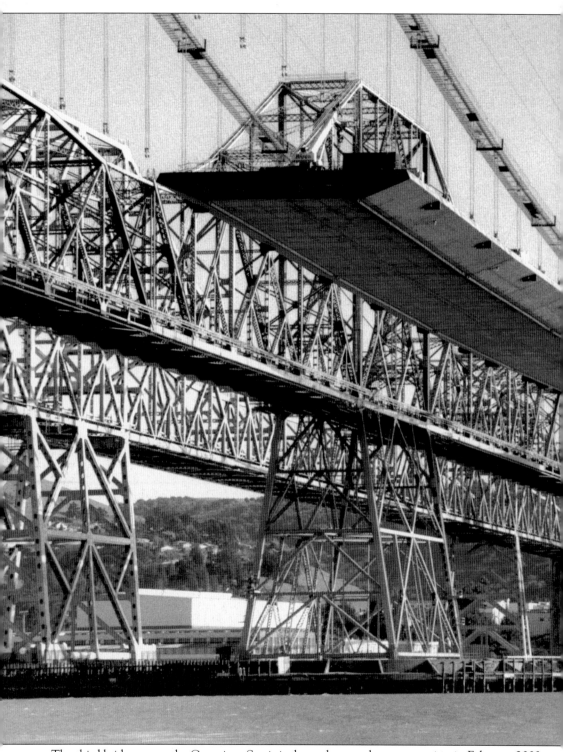
The third bridge across the Carquinez Strait is shown here under construction in February 2003. Caltrans eschewed the cantilever design of the two earlier bridges and opted instead for the

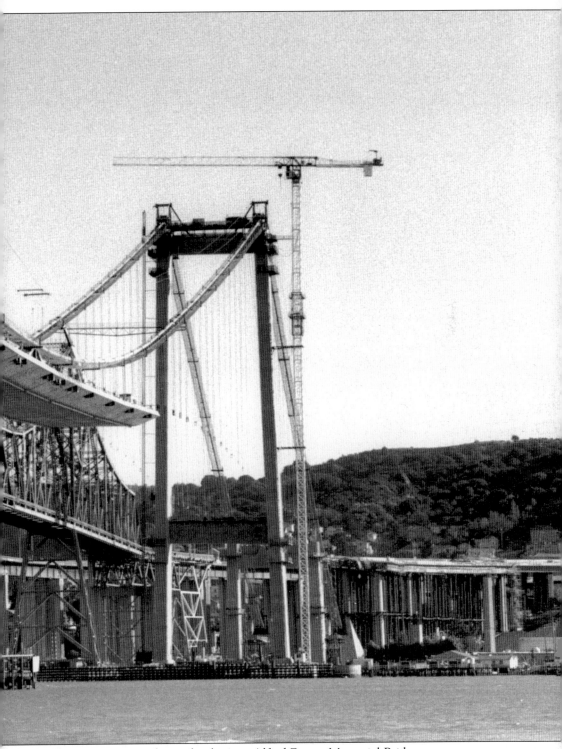
more elegant suspension design for the new Alfred Zampa Memorial Bridge.

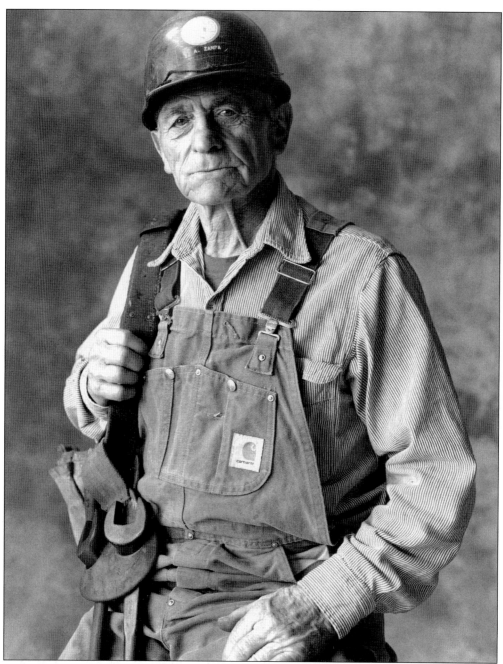

The year 1987 marked the 50th anniversary of the Golden Gate Bridge and the Bay Bridge, and was also the 60th anniversary of the first Carquinez Bridge. Alfred Zampa, who worked on all three of the great bridges, was photographed by Elma Garcia as part of the bridge celebrations.

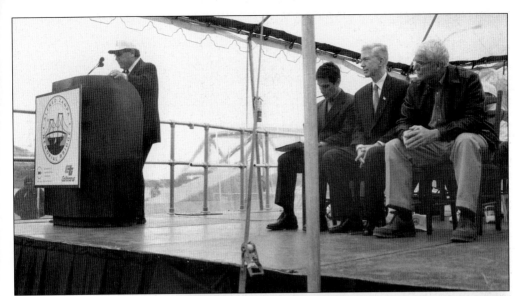

Dick Zampa, Alfred Zampa's son, speaks at the opening of the Alfred Zampa Memorial Bridge while, seated from left to right, Cal-Trans Director Jeff Morales, Governor Gray Davis, and Congressman George Miller look on.

This Bridge Builders pass was used during the grand opening of the Alfred Zampa Memorial Bridge.

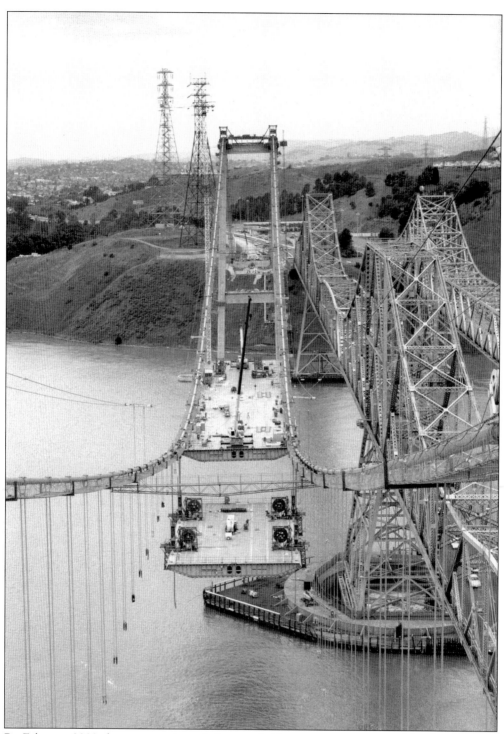

By February 2003 the construction of the new bridge was progressing swiftly. Crockett was treated to a marvelous engineering show as deck panels weighing as much as 600 tons each were lifted into place.

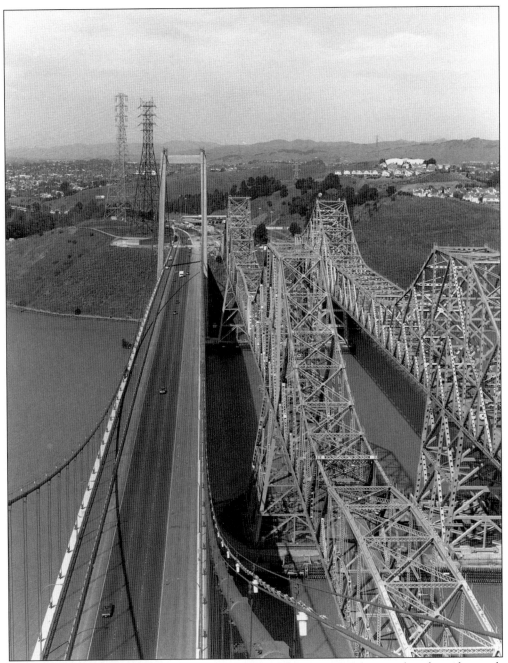

Just a year later the new bridge was open to traffic. This photograph was taken from the south tower in February 2004.

77

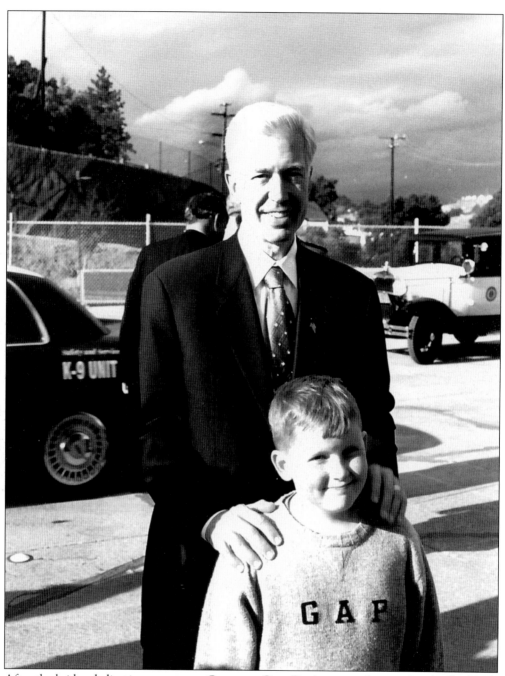

After the bridge dedication ceremony, Governor Gray Davis graciously stayed and talked with the people walking across the Alfred Zampa Memorial Bridge. Here Governor Davis poses for a picture with Kyle Robinson.

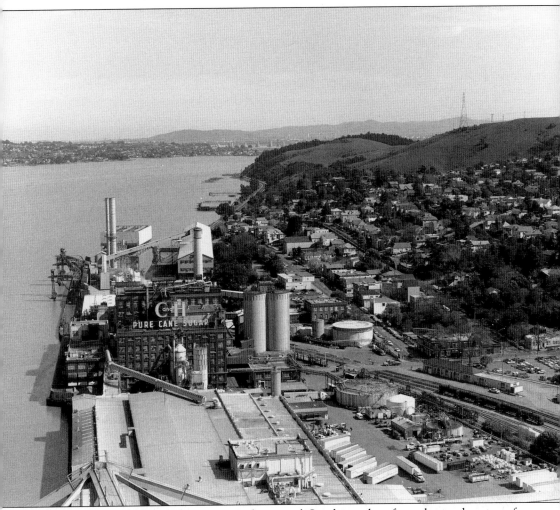
A March 2004 view of the C&H Sugar Refinery and Crockett taken from the south tower of the Alfred Zampa Memorial Bridge.

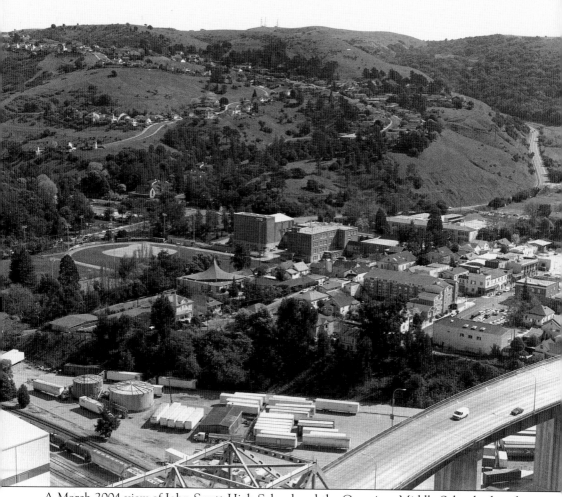

A March 2004 view of John Swett High School and the Carquinez Middle School taken from the south tower of the new bridge. This photograph shows Crockett's expansion into the hills to the south of town.

Four
CROLONA

The name Crolona is derived from splicing the first syllable of Crockett with the second half of Valona. Crolona refers to the strip of land between these two communities where Alexander Park, the grammar school, and the high school are now located. The hill overlooking Alexander Park was developed by C&H and is called Crolona Heights. This author is not aware that Crolona ever really existed as a town except in local imagination. (Did people, for example, ever list Crolona as their return address on a letter?)

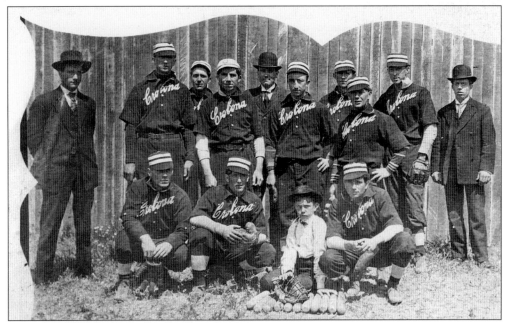

This baseball team from 1904 displays the name "Crolona."

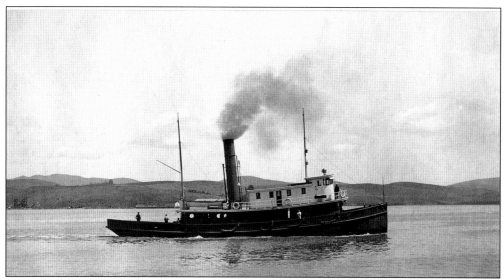

This photo from 1921 shows the C&H Sugar Refinery tugboat *Crolona* patrolling the waters of the Carquinez Strait.

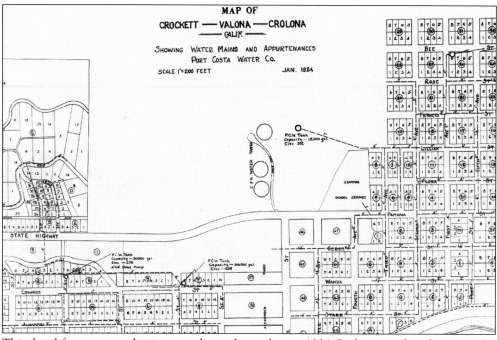

This detail from a water district map shows that as late as 1924 Crolona was listed as an entity distinct from Crockett and Valona. Perhaps the C&H Sugar Refinery had plans to develop Crolona as separate town.

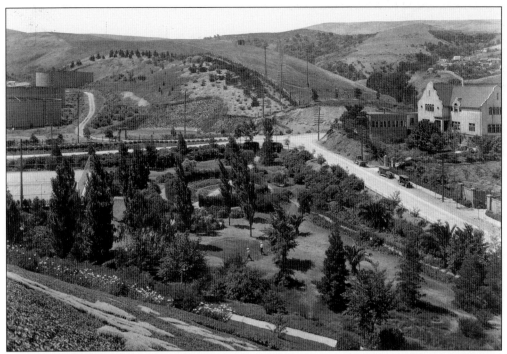

This photograph of Alexander Park was taken looking west from Crolona Heights. The old John Swett High School is on the right, c. 1921.

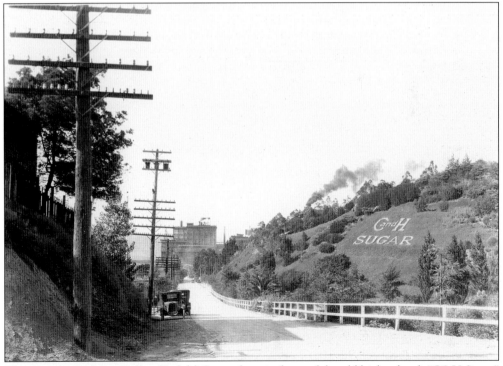

This view looks down Valley (Rolph) Street from in front of the old high school. "C&H Sugar" is spelled out in flowers on Crolona Heights, c. 1922.

83

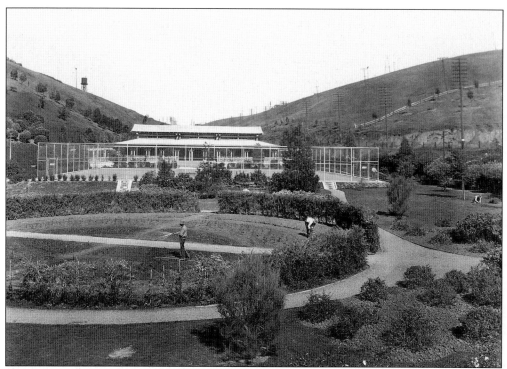

Crockett's community auditorium and Alexander Park, opened in 1920, were built by C&H Sugar Refinery for the use of the community. Over the past 84 years the auditorium has been the site of many community activities. Tennis courts were added in the 1920s and in the 1960s, when the whole complex was turned over to the Park & Recreation Association, a swimming pool was added to the grounds where the pictured gardeners are working.

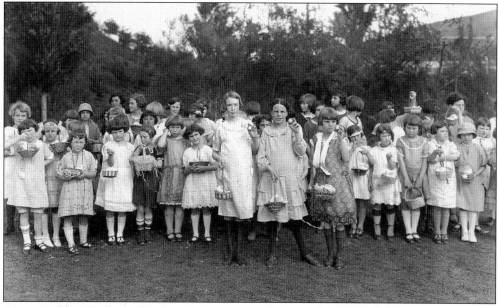

A group of local girls display their Easter eggs at the annual Easter celebration at Alexander Park in 1925.

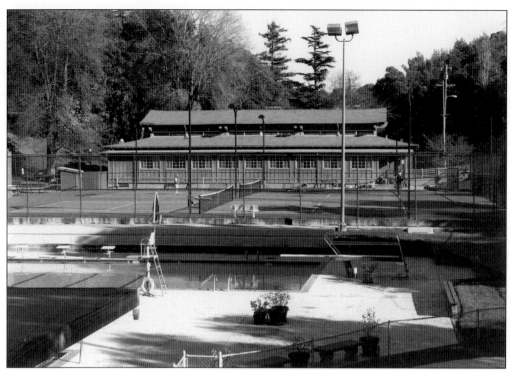

This picture shows the community auditorium, tennis courts, and swimming pool as they look in 2004. The Crockett Community Auditorium, like the Crockett library and the Crockett Club, was built in the Craftsman architectural style that was popular among California architects in the late teens and early 1920s.

Saint Mark's Episcopal Church, located on Pamona Avenue behind the Community Auditorium, was built in 1938. The parish hall was built in 1953.

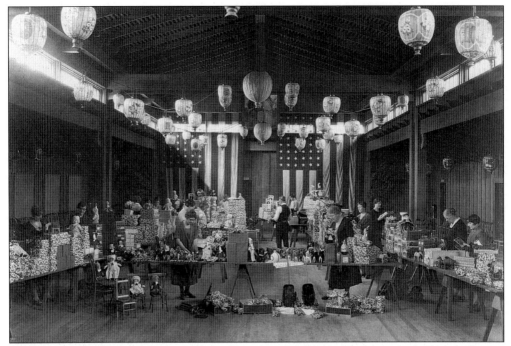
Volunteers wrap Christmas gifts in the community auditorium for the annual Christmas party sponsored by the C&H Sugar Refinery. The gifts came in four sizes: big boys, little boys, big girls, and little girls.

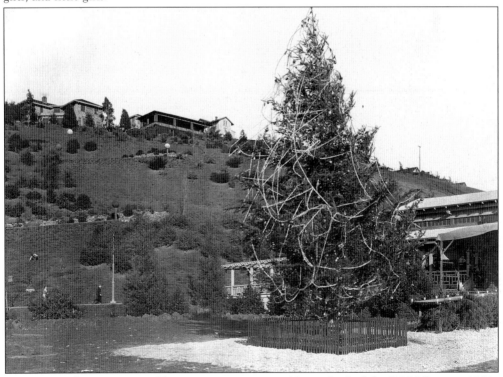
Here we see the community Christmas tree put up in Alexander Park by C&H Sugar, *c.1921*.

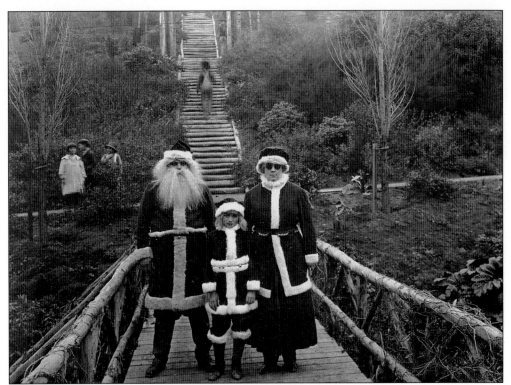
Santa Claus and family pose in Alexander Park for H.B. Hosmer in this *c.* 1921 photograph.

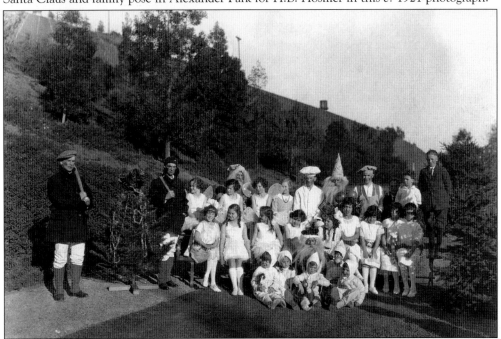
For many years the C&H Sugar Refinery sponsored a Christmas festival for the local children. This group of children and adults in this 1923 photograph are dressed to perform in the Christmas pageant.

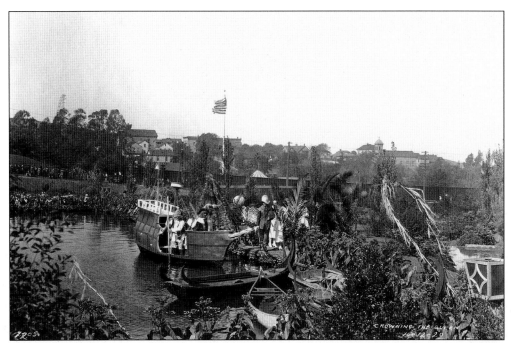

With Crockett's many Italian immigrants it's not surprising that Columbus Day is considered an important holiday. For many years Crockett held a Columbus Day celebration every October. The tradition is carried on today under the title "Festival on the Strait." The extent to which the town would go for the celebration is reflected in this 1920 photograph where Alexander Park has been turned into a manmade lake to reenact the Italian explorer's landing.

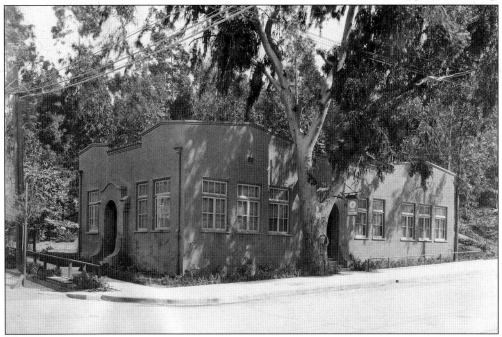

The Crockett telephone building was put into service 1923. It was the last manual exchange in Northern California when it was decommissioned in 1969.

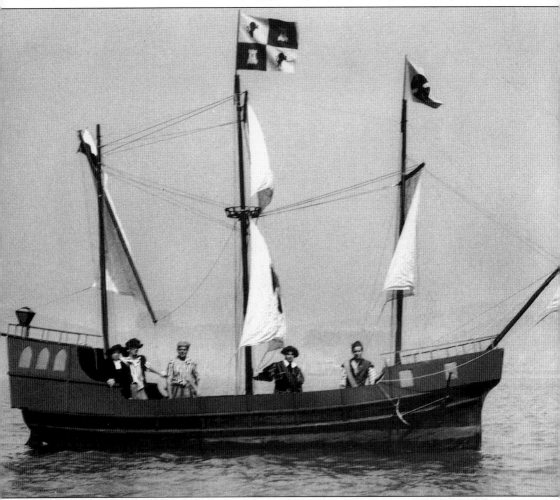

This photo from 1935 reenacts the landing of Christopher Columbus. This time the *Santa Maria* sailed down the Carquinez Strait with Valona resident Rocco Pallotta portraying Columbus. Rocco Pallotta (1863–1936) had a reputation for kindness and was affectionately referred to as the "mayor of Valona."

OFFICIAL...

Souvenir Program

Columbus Day Celebration

OCTOBER 10-11-12, 1936
CROCKETT, CALIFORNIA

This program from 1936 memorializes Rocco Pallotta, who had passed away the previous year.

This photo from the early 1920s shows local musicians decked out for a festival. Whether this is a real band or a "sym-phoney" cobbled together to amuse locals is unclear.

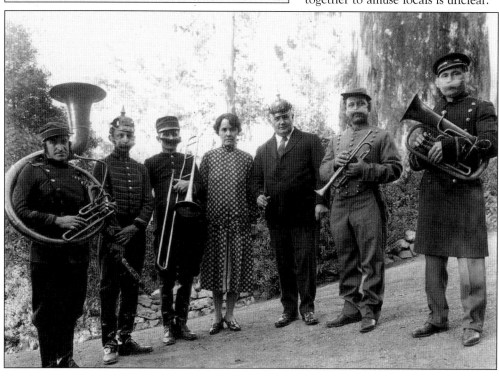

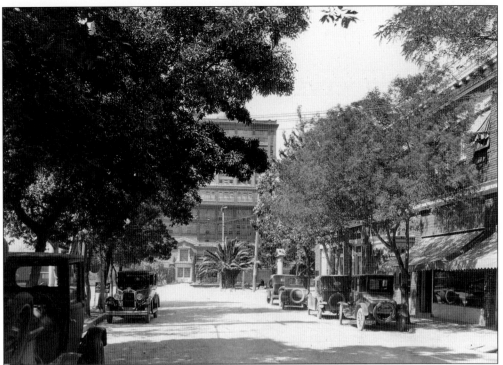

This photo, taken from in front of the Crockett Club, looks down Valley (Rolph) Street toward the intersection with Loring, c. 1920.

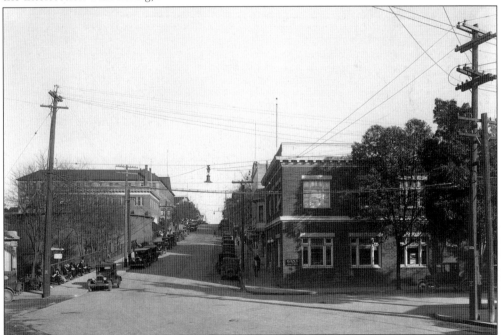

This photograph from 1923 looks east up Loring Street at the intersection of Valley Street. The Crockett Arch had recently been removed and the streets are newly paved. The Bank of Pinole building on the right is still in use as the Bank of the West.

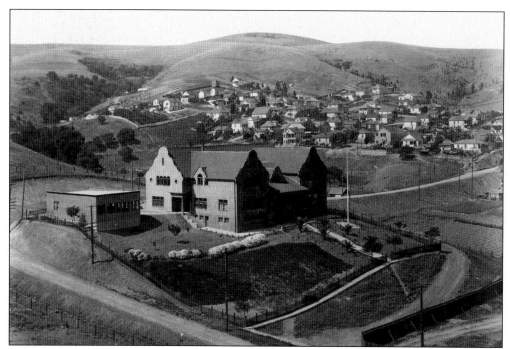
The first John Swett High School is pictured here around 1916. The school sat across Valley Street from the current swimming pool at the site of the current memorial park.

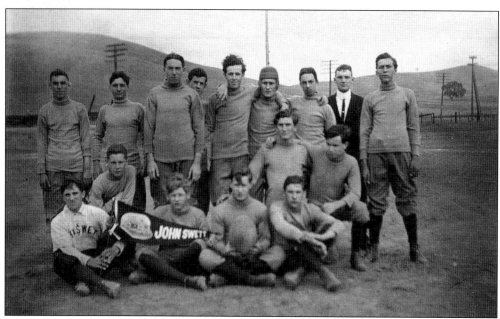
This photo shows a John Swett High School football team, c. 1910.

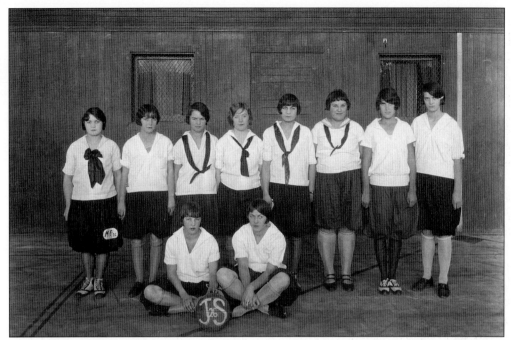

In the early part of the 20th century basketball was promoted as an ideal sport for young women because it required little equipment, could be played indoors or out, and had little physical contact. This group from 1926 shows that the sport had caught on at John Swett High School.

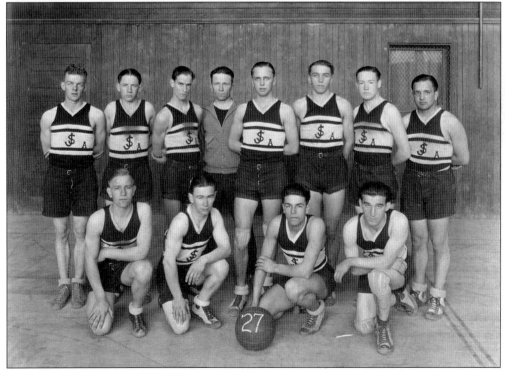

This photo shows the 1927 John Swett Union High School basketball team.

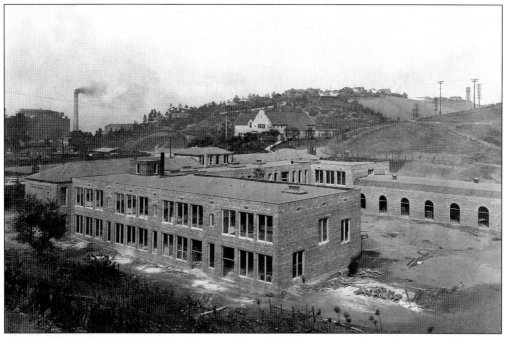
Carquinez Grammar School is shown here under construction in early 1923. Later that same year the school was open for classes. The old John Swett High School is visible in the background.

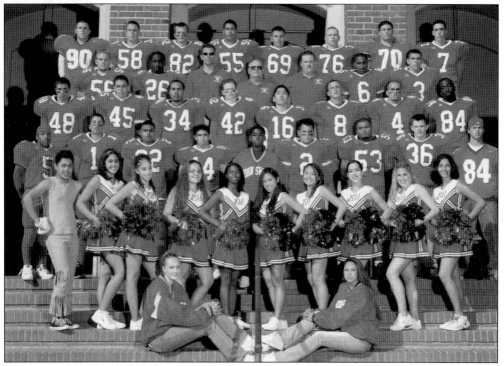
John Swett's football team, coached by John Angell, posted a perfect 10-0 record for the 2002 football season. This was the most successful team in John Swett's history.

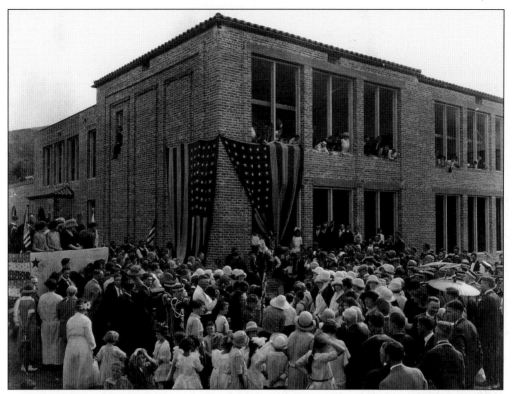

In August 1923 an enthusiastic crowd gathered at the site of the Carquinez Grammar School for the laying of the cornerstone by the Native Sons of the Golden West. The new grammar school would be ready for its first students in just a few weeks.

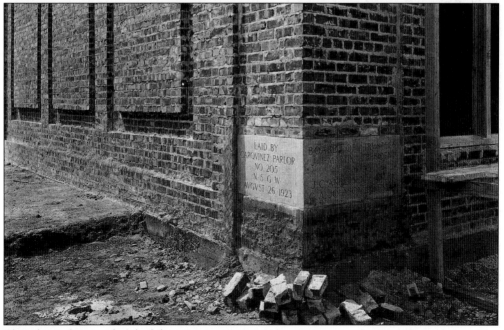

This photo shows a detail of the cornerstone.

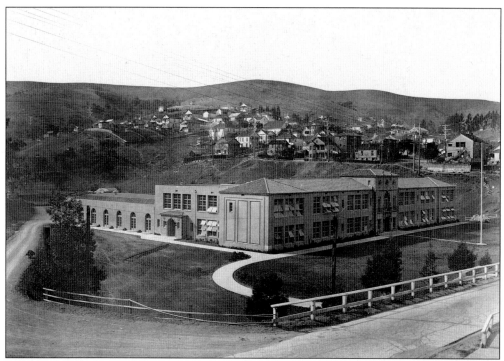

Carquinez Grammar School opened in 1923. The school still serves the community as a middle school.

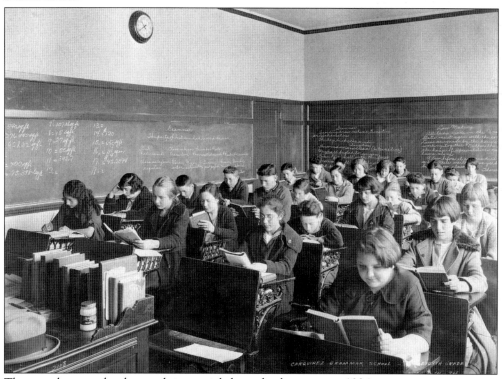

These students are hard at work in an eighth-grade classroom, *c.* 1924.

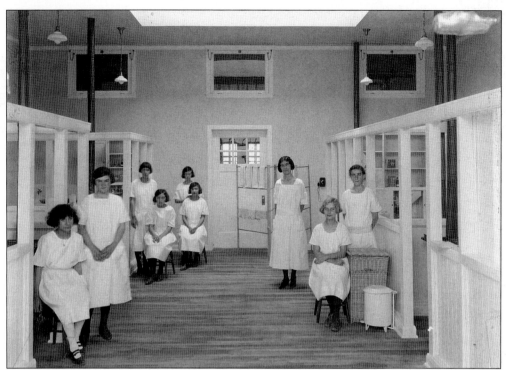

Young ladies in a "domestic science" class at the newly opened Carquinez Grammar School are shown in this photo from February 1924.

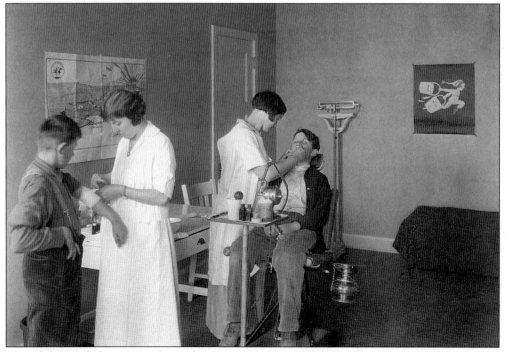

This photograph from 1924 shows the Carquinez Grammar School's nurses room. The woman on the right is doing some type of dental work.

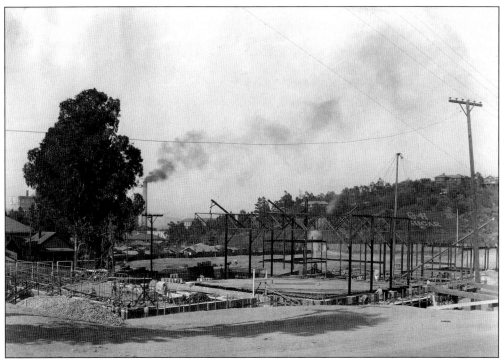

John Swett High School is shown under construction in 1926. The author has found very few pictures of the high school's construction and attribute this gap in the town's photographic record to the fact that the first Carquinez Bridge was being built at the same time and every camera in town was no doubt trained on the great bridge.

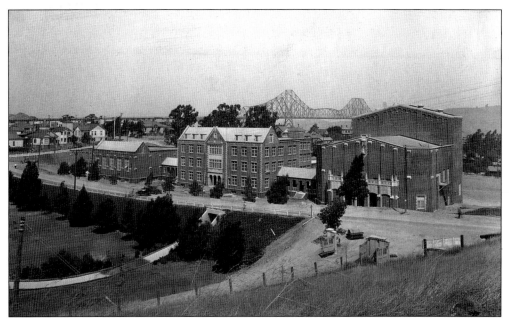

John Swett High School opened in 1927. Built across Pomona Street from the Carquinez Grammar School, both schools served Crockett and Valona.

Five
VALONA

In 1882 John Strentzel bought the land adjacent to Edwards's Crockett holdings and began to lay out the town of Valona. The town was named for a place in Europe that Strentzel thought this area resembled. His only daughter, Louise Wanda Strentzel, had a street named for her.

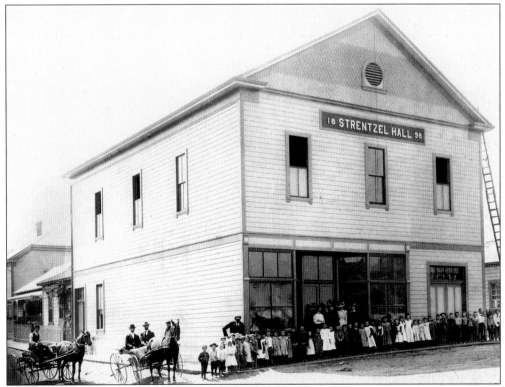

Strentzel Hall, located at the corner of Third and Wanda Streets, was completed in 1898 and named in honor of Valona's founder, Dr. John Strentzel. For a time the structure was used as a schoolhouse. This picture of the school's students and their teachers is from around 1900.

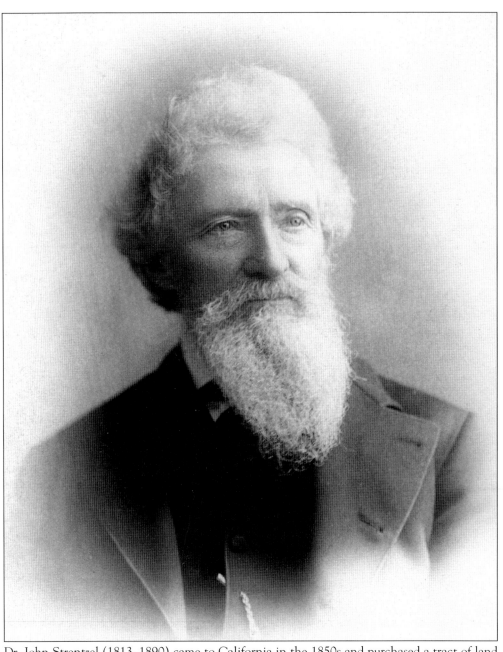
Dr. John Strentzel (1813–1890) came to California in the 1850s and purchased a tract of land south of Martinez that Mrs. Strentzel dubbed "Alhambra." (Contra Costa Historical Society.)

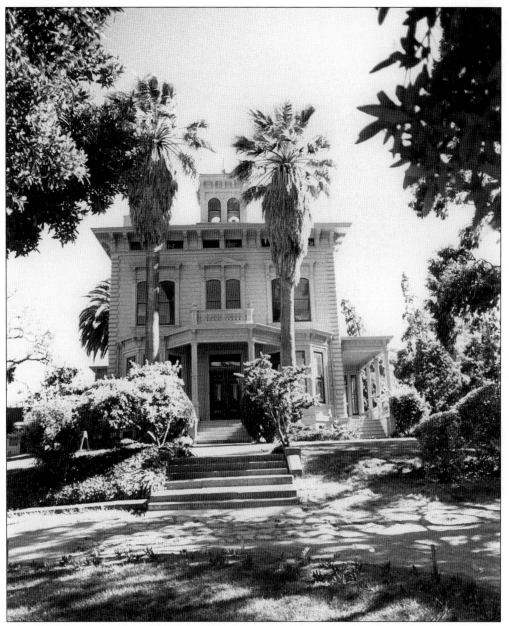

John Muir House, in the Alhambra Valley, was originally built by Valona's founder, Dr. John Strentzel. John Muir married Strentzel's daughter Wanda and the couple moved into the house, which now bears the Muir name, in 1890 after Dr. Strentzel's death.

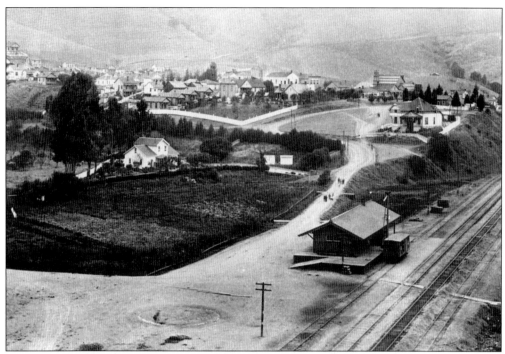

This photo looking west at the Old Homestead and early Valona was taken around 1900. Mrs. Edwards was still living, though not in the house, and must have been proud to see how much the area had grown since her family had settled the area in 1867.

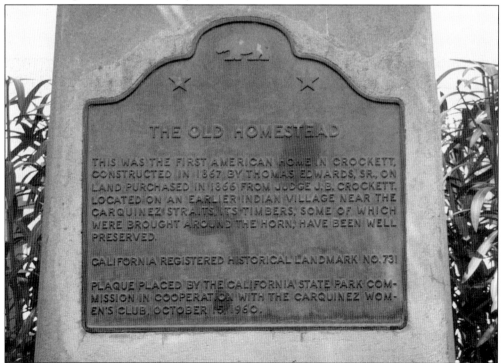

This plaque designates the Old Homestead as California Historical Landmark No. 731.

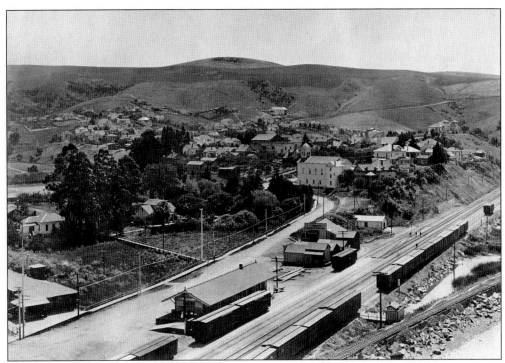

The same view from 1915 shows the old train station, the Old Homestead, Desmond's Practical Horse Shoeing, Saint Rose Church, and the Valona Grammar School on the hill at the far right.

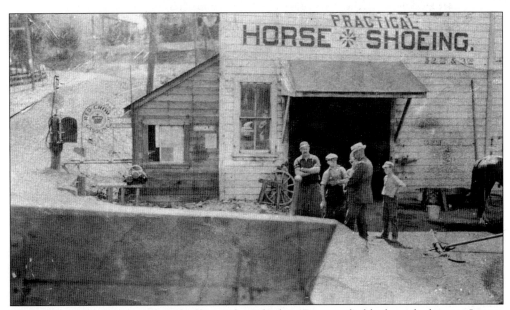

This photo from the same period offers a closer look at Desmond's blacksmith shop on Loring Street. Crockett's Auto Body now occupies the space.

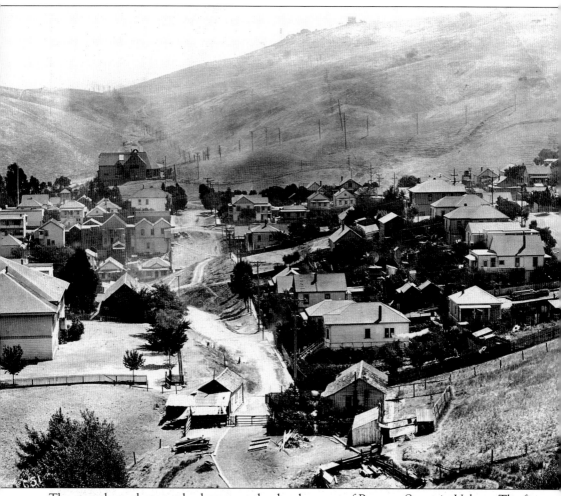

The next three photographs document the development of Pomona Street in Valona. The first photo is from 1906 and looks down the path that would one day become Pomona Street. The old John Swett High School is visible in the distance. The large building at the left of the photo is the Valona Grammar School. The gate in the foreground was used to keep livestock from wandering into town.

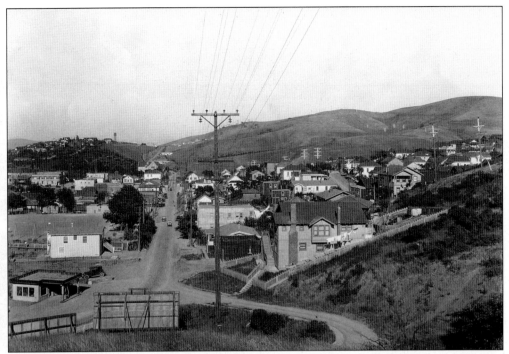

This view of Valona looking east down Pomona Street toward Crockett was taken c. 1925. The War Memorial is just visible at the top of Pomona. The Valona Grammar School is gone, replaced by a playground. The freeway and approaches to the three bridges now cut through the buildings in the foreground. The on-ramp to Vallejo now occupies the site of the old Valona School

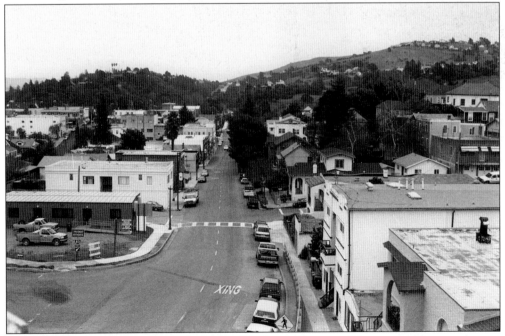

This view down Pomona Street from the Crockett off-ramp of Interstate 80 was taken in March 2004.

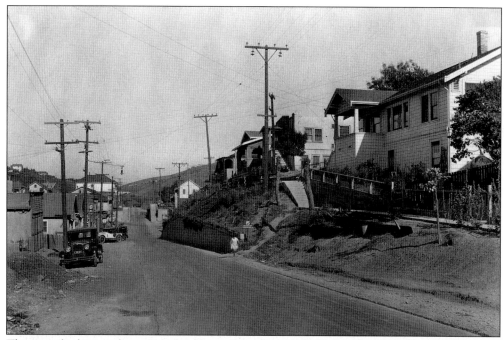
This view looks east down Pomona Street from the intersection at Port Street, c. 1921.

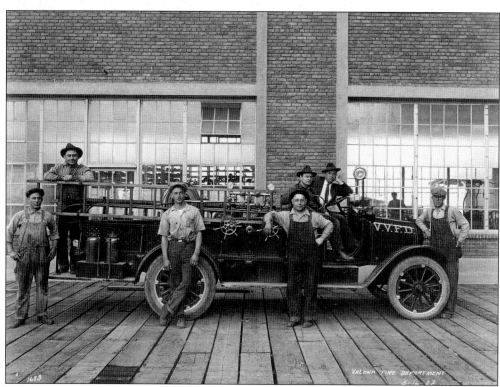
Members of the Valona Volunteer Fire Department pose with their engine for H.B. Hosmer's camera in May of 1922.

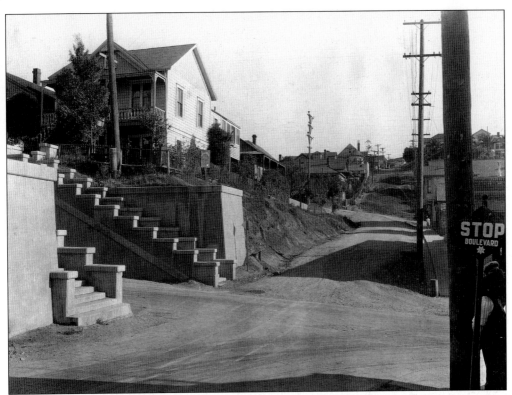
This photograph shows the intersection of Second and Pamona Streets looking south, c. 1921.

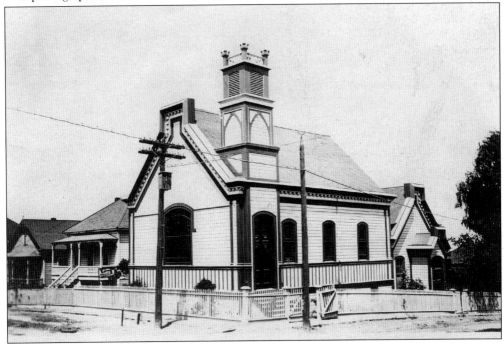
This c. 1900 photograph shows the Presbyterian Church located at Second and Wanda Streets. The church served Valona until the mid-1930s.

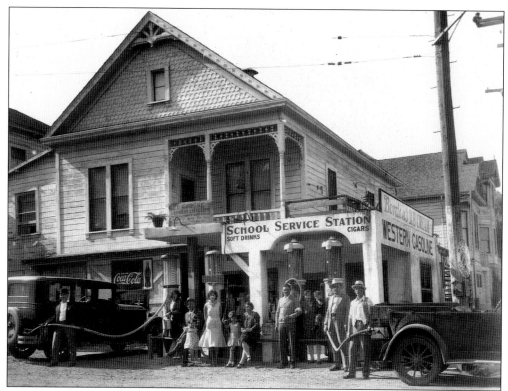

The Carone family and locals pose in front of the "School Service Station" at Pamona and Fourth Street in this c. 1930 photograph.

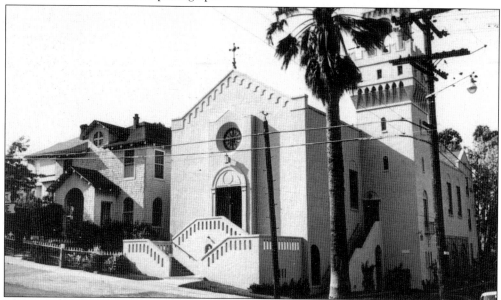

The Saint Rose of Lima Catholic Church was 50 years old when it was gutted by fire in 1962. The current Saint Rose Church was built across the street at Fourth and Starr Streets and put into service in 1967. In the interim the old Lanai Theater on Third Street was used for church services.

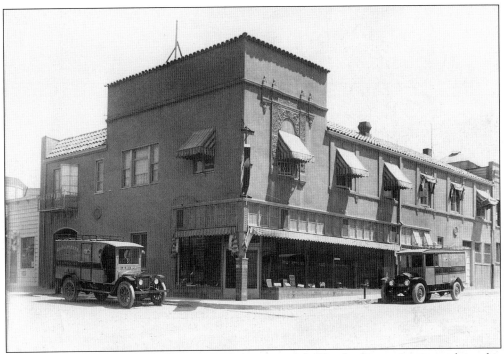

The Imerone Bakery, located at Second Avenue and Wanda Street, is pictured in this 1922 photograph.

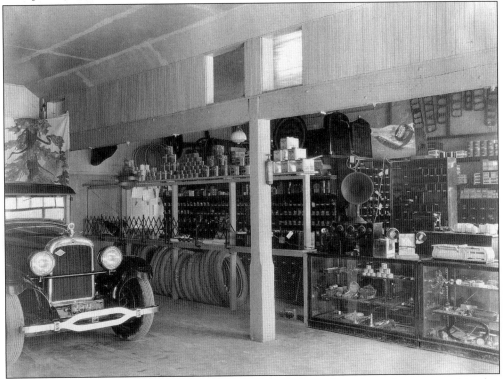

The interior of the Nash dealership shows a new car and a wide variety of spare parts for sale.

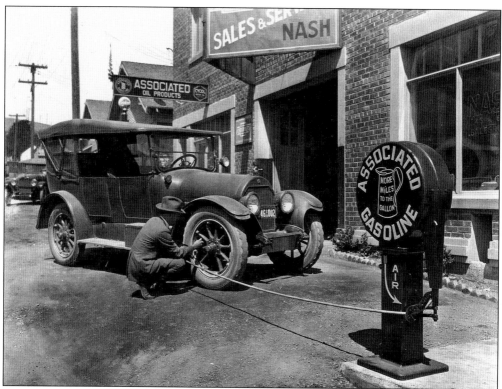

A 1923 photograph shows Antone Dowrelio's Nash dealership on Pomona Street in Valona. Today the building houses an art gallery and frame shop.

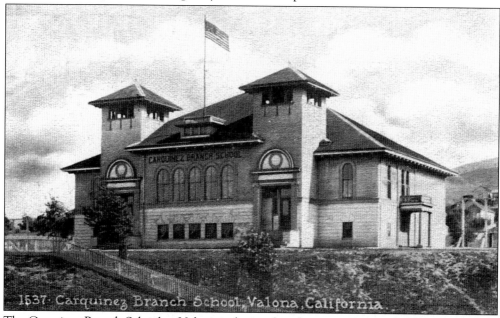

The Carquinez Branch School at Valona is depicted in this penny postcard. The school sat on Pomona Street between Sixth and Seventh Streets where the Crockett on-ramp to Vallejo now stands.

Six
VALLEJO JUNCTION

Vallejo Junction sat approximately one mile west of Crockett near Selby and was an important weigh station for travelers when Crockett was still only a whistle stop on the rail lines. A small community grew up around the train station and the ferry slip. Ferries, such as the *Amador* and the *Garden City*, shuttled people back and forth to South Vallejo. The South Vallejo ferry slip sat where the California Maritime Academy is now located.

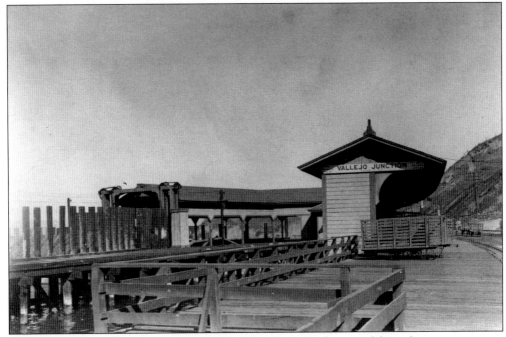

This picture from c. 1910 shows the Vallejo Junction train depot and ferry slip.

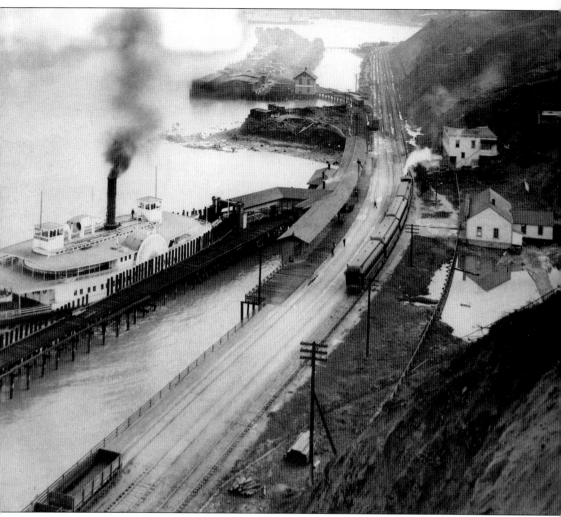

Vallejo Junction is shown here around 1900 with the ferry *Amador* in the slip. Famed author Robert Louis Stevenson (*Treasure Island* and *Doctor Jekyll and Mr. Hyde*) speaks of the area in less than glowing terms. Stevenson mentions the trip from Vallejo Junction to South Vallejo in his book *Silverado Squatters* wherein he vents his spleen on South Vallejo, describing it to be "like so many California towns. It was a blunder." The wharf of the Port Costa Lumber Company is at the top of the frame. (Contra Costa Historical Society.)

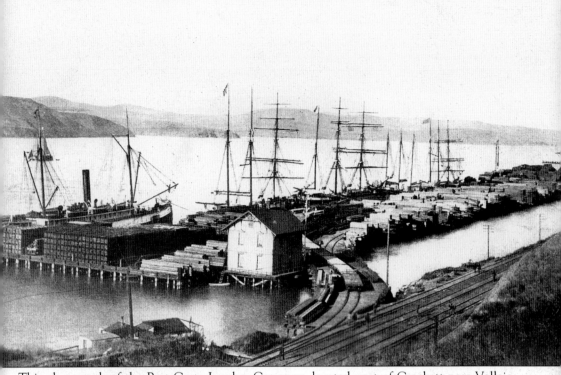

This photograph of the Port Costa Lumber Company, located west of Crockett near Vallejo Junction, was probably taken around 1895. The wharf was abandoned in the early 1900s until the bridge company rebuilt a portion of it to use as a staging area for the suspended sections of the first Carquinez Bridge.

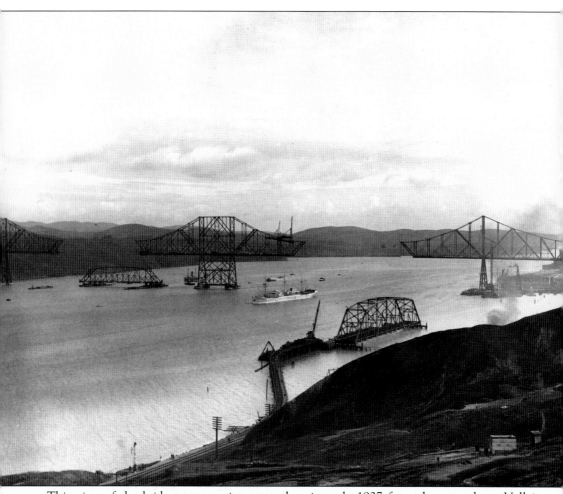
This view of the bridge construction was taken in early 1927 from the area above Vallejo Junction known as "Chat n' Chew." Visible in the center are the rebuilt docks of the old Port Costa Lumber Company, which were used to build the suspended spans of the new bridge.

Seven
SELBY

Selby was founded on the edge of the San Pablo Bay in 1883 when San Francisco Hardware man Prentis Selby purchased some waterfront acreage from John and Patrick Tormey. On the site, Selby built Selby Smelting and Lead Company to refine ores for the U.S. Mint in San Francisco. In 1884 Selby built a hotel for his employees and a small town soon arose to provide services for the workers and their families. Many of the company-owned houses were built on the site of Patrick Tormey's old ranch. In 1923 the plant was purchased and reorganized as the American Smelting and Refining Company. In 1937 the plant was expanded to include a 606-foot-high smokestack, the tallest in the world. The smokestack was one of the most visible industrial landmarks on the bay for nearly 40 years.

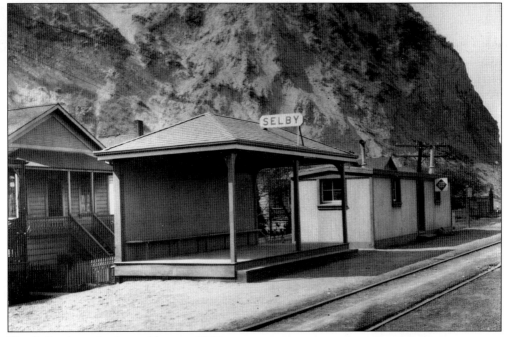

The Selby depot is pictured here *c.* 1920.

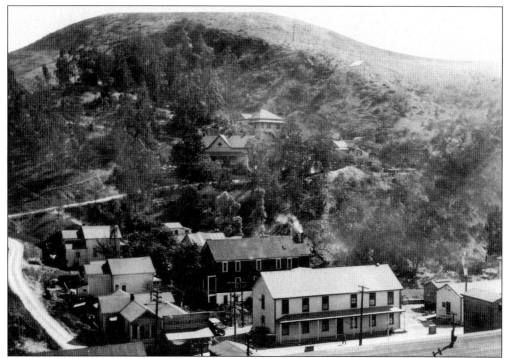

This photo from around 1920 shows the tiny village of Selby clinging to the hill south of the smelter. The little village had several homes, a small hotel, a train station, a store, and a coffee shop. The smelting company owned every building in the village and two-thirds of the homes in Tormey that lay just half a mile west of Selby.

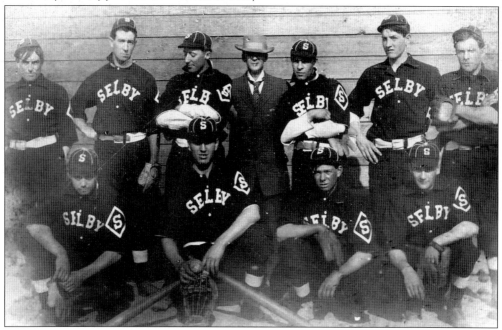

Like many companies and communities in the first half of the 20th century, Selby Smelting sponsored a baseball team. This unnamed group of athletes posed for this photo around 1915.

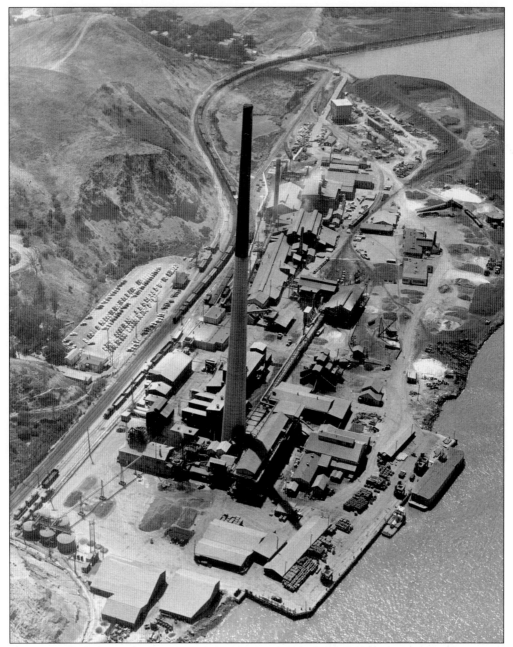

This aerial photograph from c. 1950 shows the size of the American Smelting and Refining Company plant and the huge smokestack that dominated the local skyline. The company refined lead, gold, silver, and platinum at the site for many years. By the late 1960s environmental concerns and overseas competition made the plant unprofitable and it was closed.

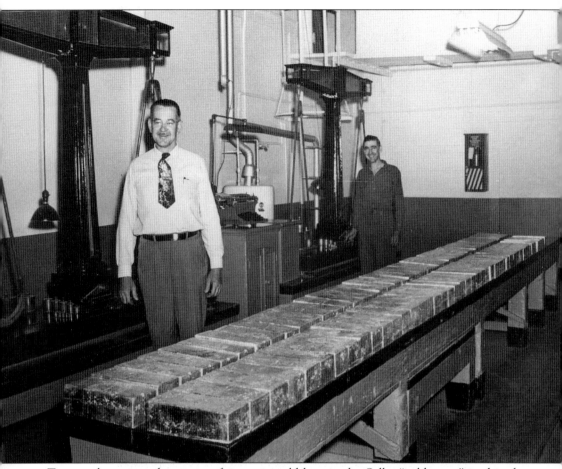

Two employees stand next to a fortune in gold bars in the Selby "gold room" in this photo, c. 1950.

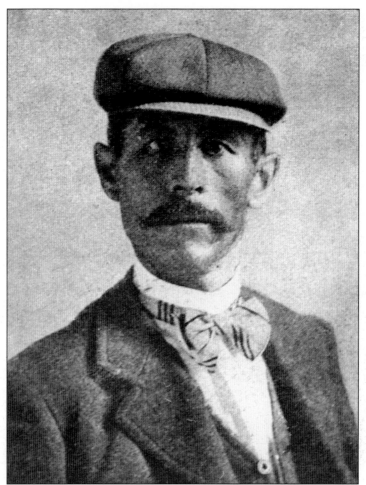

In August 1901 a disgruntled former employee of the smelter named John Winters tunneled under the floor of the gold room, drilled holes in the floor, pried open the steel floor plates, and made off with 37 gold bars worth $300,000. Suspicion quickly fell on Winters, who had abruptly left town the morning of the theft. Investigators searched his shack and found some circumstantial evidence that he was responsible for the theft, but were befuddled as to how one man could seemingly spirit away such a tremendous weight in gold bullion in only one night. After a brief manhunt, Winters was located and taken into custody for questioning. He denied any knowledge of the heist. News of the theft spread around the world and it was quickly hailed as "the crime of the century." After two days of questioning (and reading the newspaper accounts speculating about the master criminal who planned and executed this daring crime) ego seems to have gotten the better of Winters and he confessed. Winters bragged to the police that he alone had planned and carried out the crime. He hadn't taken the gold away at all. He had merely taken the gold out of the tunnel, walked to the edge of the dock, and dropped it in the shallow water. He planned to return on some dark night and retrieve his loot. The gold was quickly recovered and John Winters received a 15-year prison sentence to go along with his 15 minutes of fame.

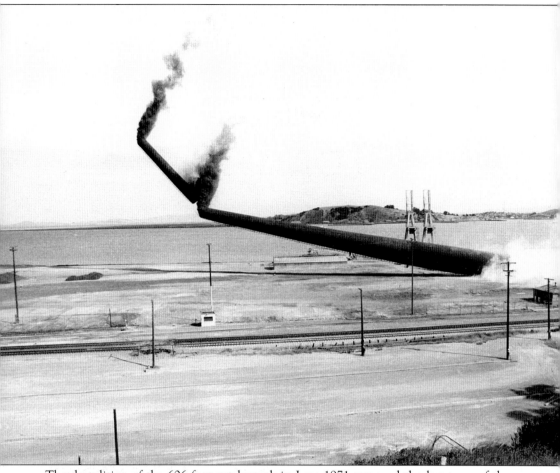

The demolition of the 606-foot smokestack in June 1971 removed the last trace of the once thriving business. All that remains of the community of Selby, and the portion of Tormey that the company owned, is the tiny two-room schoolhouse that once served the two communities. The old schoolhouse is located on B Street, at the bottom of the hill, between Crockett and Rodeo. The building now serves as the district office for the John Swett Unified School District.

Eight
TORMEY

Tormey was built on land bought from Patrick Tormey. The homes were owned by Selby Smelting and Lead. When the plant was closed, the village was razed. Only a sliver of privately owned homes remain on Old County Road. Although officially a part of Crockett, the residents and other locals still call this tiny cluster of homes Tormey.

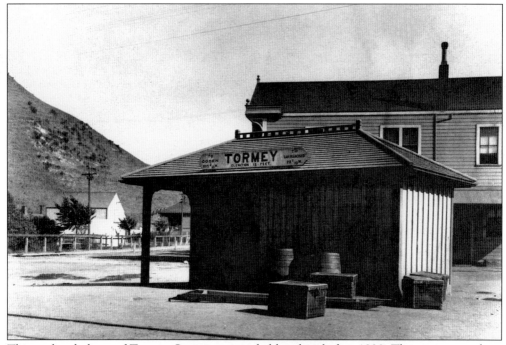

This undated photo of Tormey Station was probably taken before 1920. The station sat along the tracks near the site where Patrick Tormey's ranch house had once stood. The station was a "whistle stop" and a train only stopped if there were passengers waiting to be picked up. (Contra Costa Historical Society.)

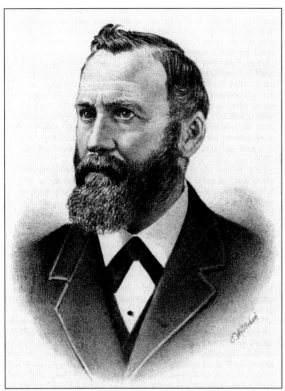

Patrick Tormey (1840–1907), along with his brother John (1825–1877), ranched 7,000 acres in west Contra Costa County, including the parcel of land that still bears the family name.

An early depiction of Patrick Tormey's ranch two miles west of Crockett shows that it had three miles of frontage along the San Pablo Bay. The ranch sat behind where the John Swett Unified School District office now sits.

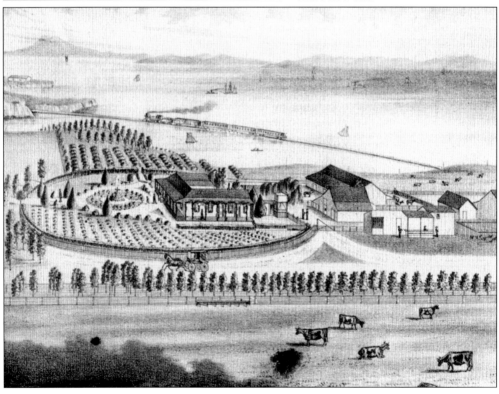

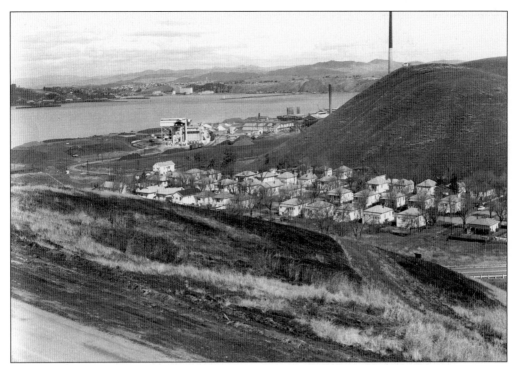
The western half of Tormey, picture here c. 1950, was owned by the American Refining and Smelting Company. When the smelter closed in 1970 the town was boarded up and finally razed in 1973.

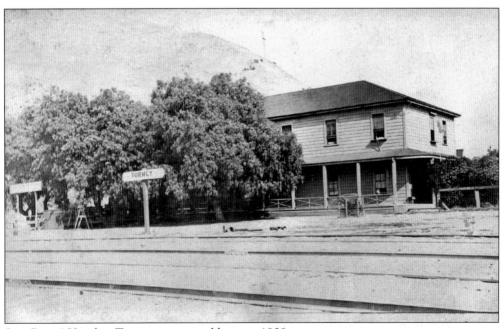
Sam Burns' Hotel at Tormey is pictured here, c. 1908.

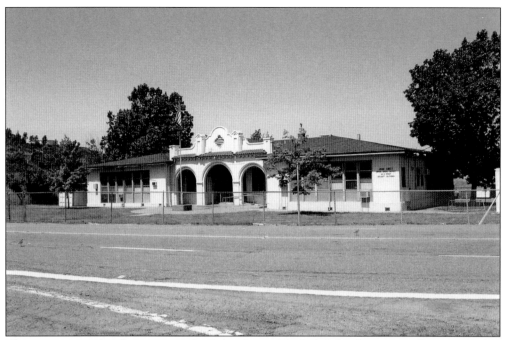

This two-room schoolhouse, now the John Swett Unified School District office, is all that remains of the western half of Tormey.

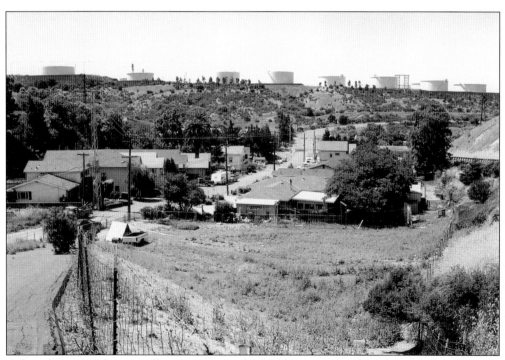

A few of Tormey's houses still remain on a stub of Old County Road. Although officially a part of Crockett, everyone still refers to this community as Tormey.

Nine
OLEUM

Named for a petroleum compound, the community of Oleum was owned and operated by the Standard Oil Company for the workers at the refinery between Tormey and Rodeo. What there was of the town sat on the hill above the current Wickland Oil terminals.

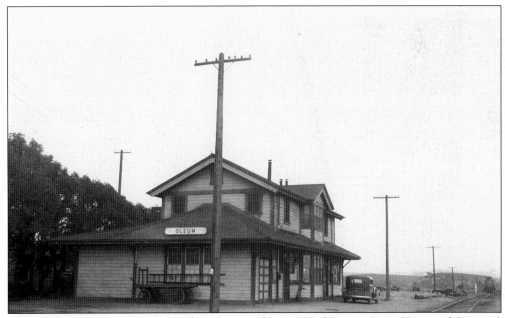

Oleum's train depot is pictured in this photograph, c. 1925. (Contra Costa Historical Society.)

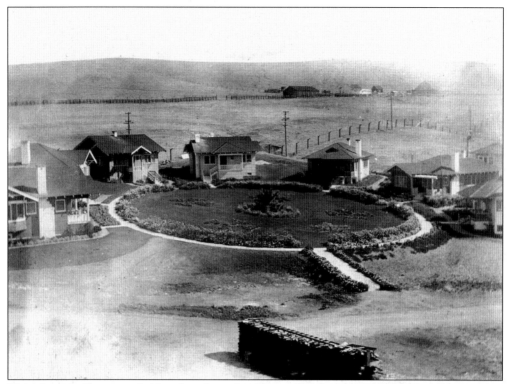
This photograph was probably taken from the Oleum Hotel and shows a circle of houses that were occupied by the plant managers, c. 1920. (Contra Costa Historical Society.)

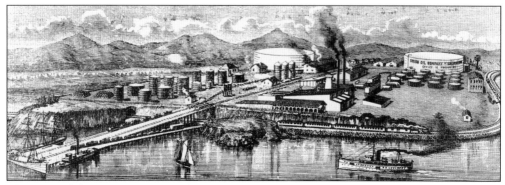
This turn-of-the-century drawing shows the Union Oil Refinery at Oleum, California.

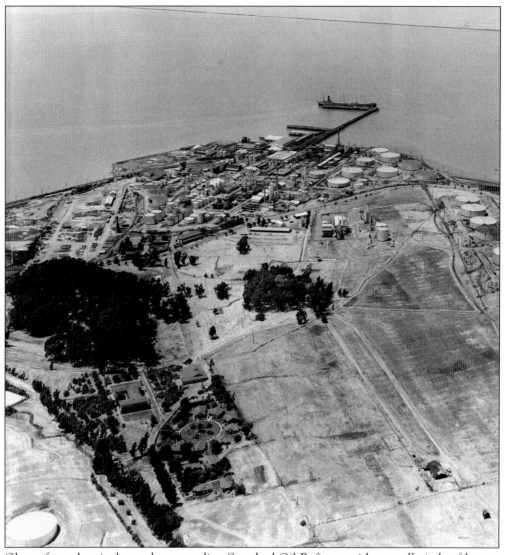

Oleum from the air shows the expanding Standard Oil Refinery with a small circle of houses and a company hotel clustered in the lower right of the photo, c. 1920. (Contra Costa Historical Society.)

REFERENCES

Billeci, David. *Crockett and its People*. Crockett, CA: Crockett Improvement Association, 1981.
Boyer, Richard. *Stories of Crockett*. Crockett, CA: Crockett Historical Museum, 1993.
———. *A Short History of Crockett*. Crockett, CA: Crockett Historical Society, 1997.
California's Contra Costa County: An Illustrated History. Walnut Creek, CA: Diablo Books, 1993.
History of Contra Costa County California. San Francisco, CA: Slocum & Co, 1882.
Illustrations of Contra Costa Co. California with Historical Sketch. Oakland, CA: Smith & Elliott, 1882.
Keith, J.D. "The Story of Crockett." Unpublished typescript in the Crockett Historical Museum, 1931.
Murdock, Dick. *Port Costa 1879–1941*. Port Costa, CA: Murdock-Endom Publications, 1977.
Olsen, Keith. Various articles about Crockett's founders. *Crockett Signal*. 1990–2003.
Robinson, John V. *Spanning the Strait: Building the Alfred Zampa Memorial Bridge*. Crockett, CA: Carquinez Press, 2004.
Staehle, Melba. "Education Resources of a Certain California Community [Crockett]." Unpublished Master's Thesis. Stanford University, 1945.
Tatam, Robert Daras. *Old Times in Contra Costa*. Pittsburg, CA: Highland Publishers, 1993.